IMAGES
of America

THE WHITE HOUSE,
THE CAPITOL, AND THE
SUPREME COURT
HISTORIC SELF-GUIDED TOURS

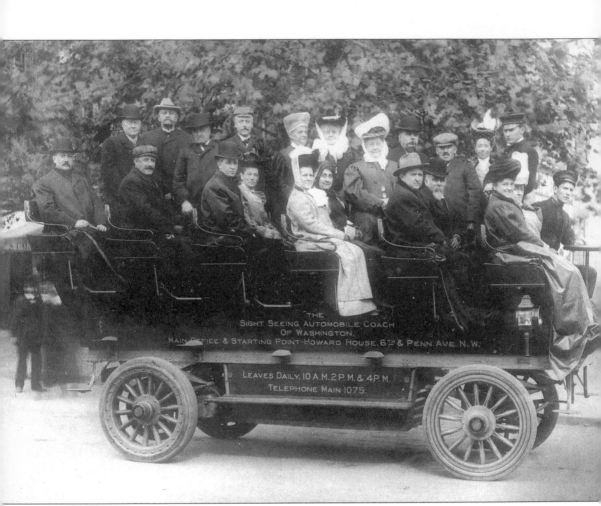

A Tour Vehicle Operating in Washington, D.C., in the late 19th Century.

IMAGES
of America

THE WHITE HOUSE, THE CAPITOL, AND THE SUPREME COURT
HISTORIC SELF-GUIDED TOURS

Thomas J. Carrier

ARCADIA

First published 2000.

Published by Arcadia Publishing,
an imprint of Tempus Publishing, Inc.
2 Cumberland Street
Charleston, SC 29401

Printed in Great Britain.

Library of Congress Catalog Card Number: 99-069831

For all general information contact Arcadia Publishing at:
Telephone 843-853-2070
Fax 843-853-0044
E-Mail arcadia@charleston.net

For customer service and orders:
Toll-Free 1-888-313-BOOK

Visit us on the internet at http://www.arcadiaimages.com

ACKNOWLEDGMENTS

A special thank you goes to the following individuals: Mary Ternes of the Washingtoniana Division of the Martin Luther King Public Library, whose extensive collection and patient help made this book a reality; Natalie and Edward Hughes at Bookhouse (bookhouse.com) for their constant support; Dr. Barbara Wolanin, curator in the Office of the Architect of the Capitol and her great staff; Jimmy Warlick of Political Americana and Nick Artimovich for their special help; Gail Redmann, librarian of the Historical Society of Washington, D.C., for her professional help; Ted Daniel and his staff of the Capitol Guide Services, Franz Jansen of the Supreme Court, and Scott Strong of the U.S. Senate Curator's office, for their enthusiasm and support; and the folks at Action Photo in Arlington, Virginia, for all of the great historic photo reproductions.

Special dedications are reserved for Arlene Bournia, whose special support will always be why I can put my thoughts into action; Christine Riley, my editor at Arcadia Publishing, for her great patience and continuous support; and to my wife, Inés, who encouraged, supported, and at times suffered, me throughout the process (y gracias especialmente a mi suegra, Crystell del Solar, por su paciencia). Most importantly, love to Ma and Dad, who are always there no matter what.

CONTENTS

ABOUT THE AUTHOR

Tom Carrier has been a licensed tour guide in Washington, D.C., since 1995, but has given unofficial tours since 1977. He is also the author of *Washington, D.C.: A Historical Walking Tour*, *Historic Georgetown: A Walking Tour*, and *The Historic Walking Tour of Alexandria 1749*. He has given specialized tours at the White House to the Curator and the Secret Service and was a costumed interpreter for the National Park Service at the Old Stone House in Georgetown. He is a past member of the Arlington County Travel and Tourism Commission, a current member of the D.C. Heritage Tourism Coalition, and a Friend of the D.C. Guild of Professional Tour Guides of Washington, D.C.

SPECIAL NOTES

Each public tour reflects these buildings as they existed in November 1999. Each building may change the public tour at any time. The White House may close the public tour for official events without notice. The West Wing, including the Oval Office, and the private second floor are not on the public tour. Please stay within prescribed areas and obey all restrictions, especially concerning the taking of photographs. Statues and paintings may be changed or moved without notice. All information is as correct as public sources allow and may differ from official versions. Still, I take responsibility for all obvious errors.

INTRODUCTION

The Federal City, as it was called when it was developed from fields, marshes, forest, and farmland beginning in 1790, is now known the world over as Washington, D.C., the capital of the United States. It was established when the Constitution of the United States was passed in 1787, but it is kept alive by the inherent rights of its citizens to peacefully govern themselves.

Here, the president (who must be at least 35 years old and a natural-born citizen), elected every four years through individual votes that influence the final electoral college tallies to win, presides over 13 administrative departments providing the day-to-day management of a country comprised of 50 states, several territories, and 280 million people. The executive office of the president enforces the laws from the White House, a relatively small building when compared to others today, perhaps, but very large when it was built beginning in 1792. Since then, it has not changed as much as it has been modified and expanded.

Congress, the national assembly, debates and then passes all national legislation. The Constitution created two separate houses, the Senate (upper house) and the House of Representatives (lower house). The Senate consists of 100 members, two from each state, which gives each state, large or small, an equal vote in at least one house. Every six years, only one-third of the Senate's members seek reelection at a time in order to provide security and continuity to government. The 435 members of the House of Representatives seek election as a group every two years. This was in line with the founding fathers' desire that representative government should be forever fluid and keep its members close to the people they represent.

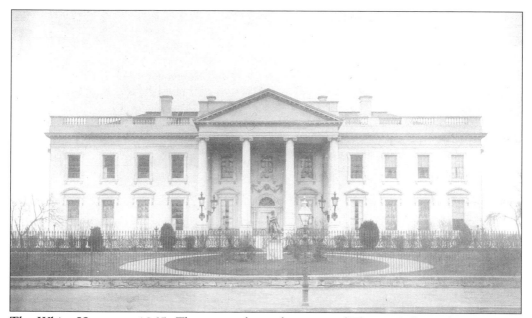

The White House, c. 1865. This image shows the statue of Thomas Jefferson by P.J. David d'Angers that is now in the Capitol Rotunda (see page 46).

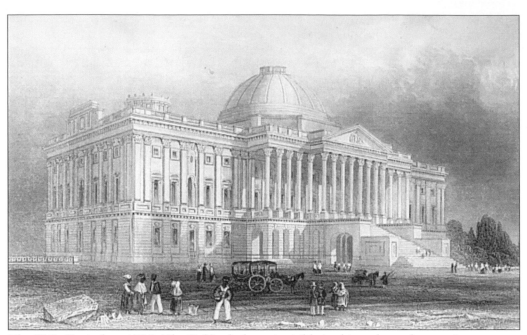

The U.S. Capitol, c. 1830. The Bulfinch dome is visible in this early steel engraving.

Separately, but equally, the halls of justice stand alone, unto themselves. Known as the Supreme Court of the United States, the decisions of nine individuals appointed by the president determine the legality of laws, not the rightness of man. Once appointed by the president and confirmed by the Senate, each justice serves for life or at will. As a group, they do not report to anyone or to each other. They are beholden only to the Constitution of the United States, which includes the first ten amendments, known as the Bill of Rights, and the subsequent 16 amendments, or changes to the Constitution. Among these amendments are the freedom of speech, the freedom of religion, the freedom of association, and the freedom to vote, all of which remain paramount for every citizen of the United States.

Each branch of government bears a unique responsibility to respond to the needs of its citizens but must also check the excesses of the other branches; laws are passed by Congress, approved by the president, and, if necessary, reviewed by the Supreme Court. It is a system of government that has lasted since the nation's declaration of independence from Great Britain, and celebrated each year since, on July 4, 1776. It is sure to last generations more.

Many who read this book have taken public or private tours of at least one, if not all three, official buildings outlined here: the White House, the Capitol, and the Supreme Court. Here, you will learn more about the paintings, portraits, busts, and other architectural details of each of these buildings, and, as you progress, you will learn about 300 years of United States history.

It should be understood that each of these self-guided tours follows along the conventional public tour route only (at least as they were in 1999). Your tours will not go beyond the official tours. For a complete history, purchase the official guidebooks for each of these buildings from the gift shops onsite or from their respective historical associations. What I intend to provide you here are photos or images that provide a different, more historic, view of these treasured buildings.

In the White House, for example, you will see the official rooms through the cameras of 1900 and see for yourself the changes that have been made, and not made, over the past 100 years. The Tiffany screen of the Victorian era in the Center Hall is gone, and the staircase near the State Dining Room was taken down in 1903. But you can see them on these pages.

Some of the noticeable features of the Capitol of 100 years ago are the near darkness of its hallways from inadequate lighting and the total lack of metal detectors. Still, numerous changes are evident, especially in the placement of statues, busts, and paintings. You will learn more about the history of the United States in these halls than in the White House or Supreme Court—from the lives of early Native Americans to the memorials of space travel. You can also explore the early architecture of the original building of 1800 and its most recent expansions.

While the Supreme Court has only had its own building since 1935, its site is alive through original photos of the Old Brick Capitol and the Capitol Prison. Each justice from John Marshall through the Warren Court is equally represented throughout your visit. While its true that for most of its life the Supreme Court was a roving child with no permanent place to call home, you will soon sense the simple majesty and quiet dignity that it has always had.

I hope that your visit within the three branches of government will provide a better understanding of the people and events that have made the United States of America a great country. When you know your history, you can begin to know yourself. Enjoy your tours.

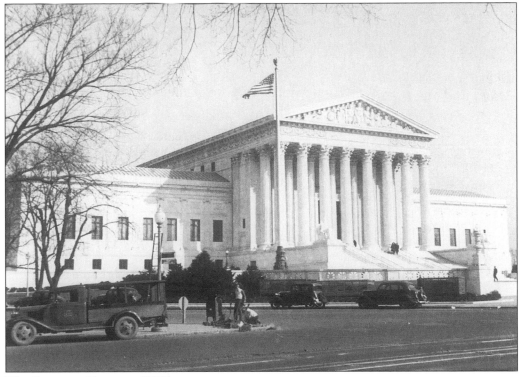

The Supreme Court, c. 1935.

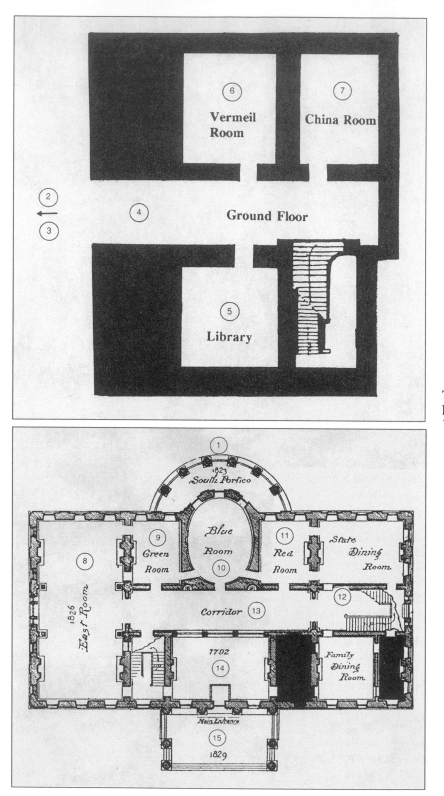

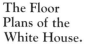

The Floor
Plans of the
White House.

TOUR A

INSIDE THE WHITE HOUSE

*". . . [m]any first families loved this house—and that each and every one
left something of themselves behind in it."*

—Jacqueline Kennedy, 1962.

The White House is located on what was once farmland and orchards owned by David Burnes, an original landowner. In 1790, Major Pierre L'Enfant included Burnes's farm as the site for the Presidents House and Presidents Square, but Burnes refused to sell. It took George Washington, himself, to finally convince him to sell the land for the Presidents House. Burnes kept his farmhouse on the site of the Organization of American States building at the corner of Seventeenth Street and Virginia Avenues and, to spite everyone, continued to plant crops in the street in front of his farmhouse.

During the British occupation of the Federal City in 1814, the White House, the Capitol, and other public buildings were completely gutted by fire. The only item saved in the White House was the Gilbert Stuart portrait of George Washington that now hangs in the East Room. The White House was rebuilt and reoccupied by 1819. In 1824, the South Portico was added; in 1829, the North Portico was completed; and in 1902, President Theodore Roosevelt added the West Wing to serve as presidential offices. From 1948 to 1952, President Harry Truman lived in Blair House while the mansion was completely gutted in order to remove the original wooden timbers and replace them with steel beams and to add modern wiring, plumbing, and central air conditioning.

Since 1789, every president, except George Washington, has lived in this house. Every four years in November since then, a new president is elected or reelected for a second term (the 23rd amendment to the Constitution limits the president to two terms). On Inauguration Day the following January 20th at precisely noon, the new or reelected president is sworn in and freedom is peacefully renewed.

Please note that the West Wing is not on the public tour, since that is where the president's Oval Office is located and where the Cabinet secretaries (there are currently 13) meet on the day-to-day management of the government. They are probably working as you are visiting.

Site 1: South Portico. You will first see the south side of the White House and its grounds as you begin your guided tour from the White House Visitors Center. Built of Seneca sandstone, the South Portico was added to the White House in 1824 (the balcony would be added in 1947 under President Harry Truman). Before 1824, there were no ionic columns or stairways. James Hoban seems to have been inspired to create the South Portico from a similar design embodied in the Chateau de Rastignac at Perigord, France, but no documentation exists to connect the two. Today, the South Portico of the White House serves as a pleasing backdrop for special and historical events held on the south lawn by the president throughout the year.

SOUVENIR
DISTRIBUTED ON THE OCCASION OF THE VISIT OF THE PHILATELIC TRUCK

ISSUED BY THE
UNITED STATES POST OFFICE DEPARTMENT

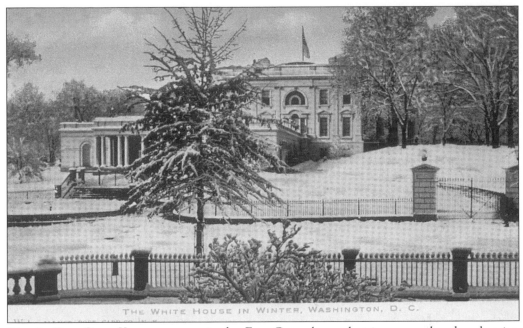

THE WHITE HOUSE IN WINTER, WASHINGTON, D. C.

Site 2: East Gate. Your next stop is the East Gate along what is now a closed pedestrian walkway (created as a security measure in 1986) but was originally East Executive Avenue. As you go through security, notice the eagle surrounded by stars on the belt buckle and shoulder patches of the security officer. This is the presidential coat-of-arms of which you will learn more later. As you enter the White House, please observe all rules, especially the regulation prohibiting the taking of photographs or videos while inside. The winter scene on the postcard shown above was taken about 1940.

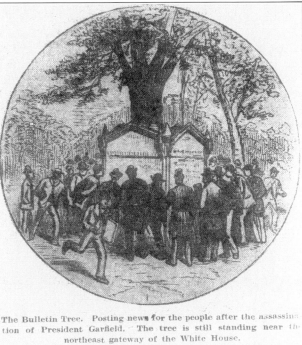

The Bulletin Tree. Just at the end of East Executive Avenue at the northeast White House gate stood the Bulletin Tree. Here a drawing shows reporters getting information about the assassination of President James A. Garfield in 1881. No subsequent information about the tree has been uncovered yet.

The Bulletin Tree. Posting news for the people after the assassination of President Garfield. The tree is still standing near the northeast gateway of the White House.

13

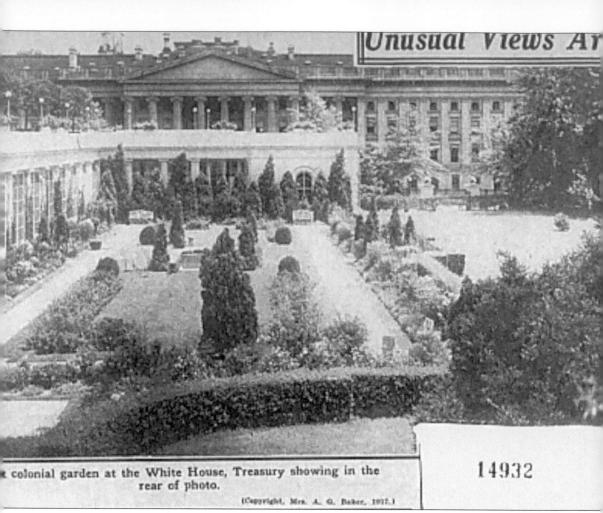

colonial garden at the White House, Treasury showing in the rear of photo.

(Copyright, Mrs. A. G. Baker, 1917.)

14932

Site 3: The East Wing Lobby. This wing of the White House was built in 1942 and eventually became the office of the First Lady. As you walk, you will pass through the Garden Room, which is appropriately named, since just outside is the Jacqueline Kennedy Garden. The First Lady uses this garden as an informal reception area. The photo you see here shows the same garden as seen in a newspaper about 1917.

As you pass through to the Ground Floor Corridor, stop and pick up a copy of *The White House* tour book, the official book from the White House Historical Association. It provides a more comprehensive historical guide to the rooms you will visit today. Each purchase helps with the maintenance of the White House furniture, rugs, chairs, tapestries, and other needed renovations throughout the year. And please, by all means, ask questions of the officers assigned to each of the rooms.

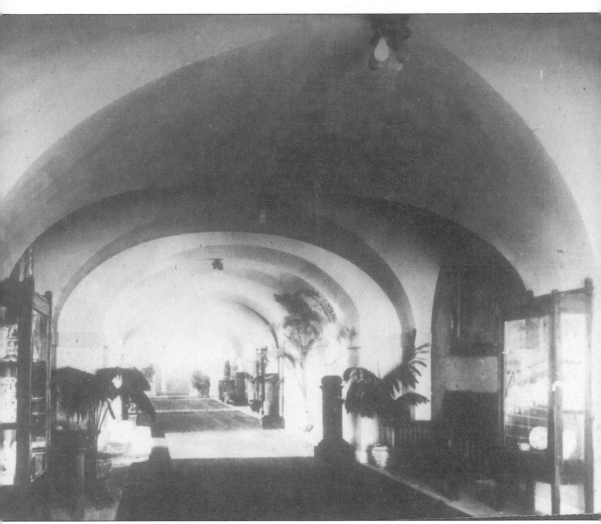

Site 4: The Ground Floor Corridor. When architect James Hoban designed the White House in 1800, this basement area was used for storage and held servant rooms. The original kitchen was nearby, but has since been moved. President Abraham Lincoln (1861–1865) was said to have remarked that this area had "the air of an old and unsuccessful hotel." During heavy rain, it flooded constantly, giving it a musty, damp smell. In 1902, the White House renovation transformed this basement area to emphasize its vaulted ceilings and marble floors. The placement of antique furniture and works of art—particularly the portraits of the First Ladies—and the small display of the White House China make this a memorable room.

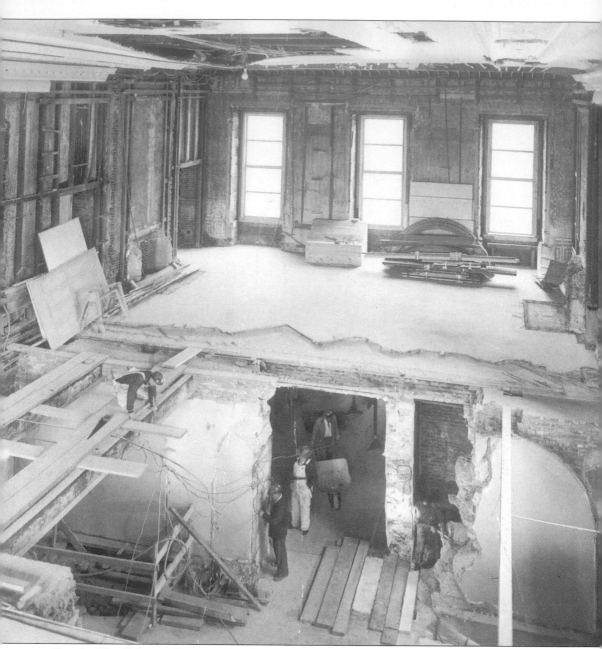

Site 5: The Library. Former schoolteacher Abigail Fillmore, the wife of President Millard Fillmore, moved into the White House in 1850 and found no central library. She persuaded Congress to appropriate $2,000 to begin a library in the upstairs Oval Room (now the Blue Room). The American Booksellers Association volunteered its resources and donated the first complete library in the 1930s, and the library was relocated to its present location soon thereafter. Today, the library is a great collection of books by American writers. It was also here that Presidents Franklin Roosevelt and Jimmy Carter conducted their "fireside chats," the first by radio and the second by television. This photo from photographer Abby Rowe shows the Library on the ground floor during the 1952 renovation of the East Room on the first floor.

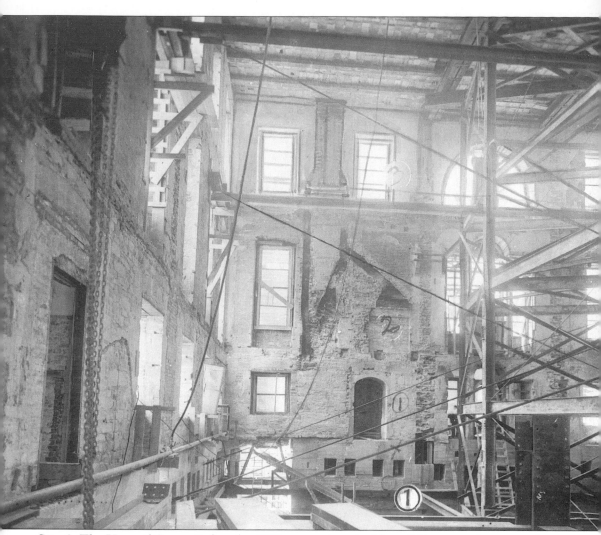

Site 6: The Vermeil Room. Before the 1952 renovation, the Vermeil Room was known as the Billiards Room. After the renovation, it became the Gold Room to highlight the silverware that was housed there. Called vermeil, a process developed in Europe in the 13th century in which gold is fired onto silver by means of mercury, the pieces are sterling silver on the inside but dipped in pure 24k gold. To clean vermeil, it is said that champagne works best—naturally. All of the vermeil pieces were donated to the White House by Margaret Thompson Biddle in her will of 1956. President and Mrs. Eisenhower accepted the donation and had the collection displayed in 1957. Valued at nearly $100,000 at the time of its donation, the collection is probably worth more than a few million dollars today. It beautifully complements the furnishings and original vermeil flatware bought by President James Monroe in 1817. This photo shows the 1952 renovation in progress (no photos of the Billiards Room were found for publication) taken from the files of White House photographer Abby Rowe. The lower circled "#1" shows the basement where the Vermeil Room, one of many rooms that would be reconstructed, was located.

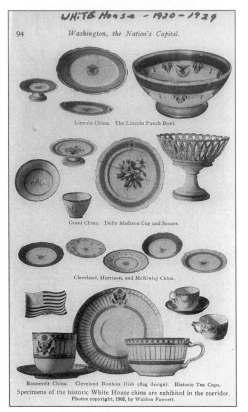

Site 7: The China Room. Beginning in the 1870s, it became customary for the incoming administration to create its own distinctive state china. Displaying presidential china in a museum setting began with Mrs. Edith Roosevelt, the wife of President Theodore Roosevelt. She purchased special wooden cabinets to display the china of past presidential administrations. Mrs. Edith Wilson, the second wife of President Woodrow Wilson, finally designated The China Room to permanently house the continuing collection. Today, virtually every administration from George Washington to Ronald Reagan—over 200 years of U.S. history—is represented through the display of the distinctively designed presidential china and glassware.

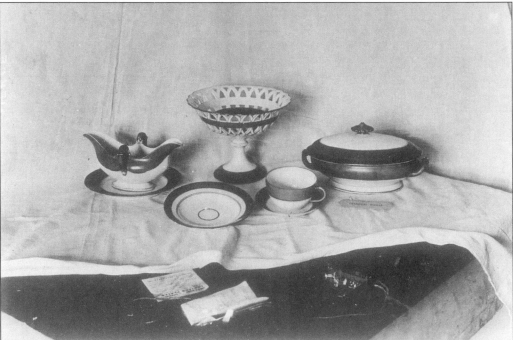

White House China for Franklin Pierce. Pierce served as the 14th president of the United States between 1853 and 1857.

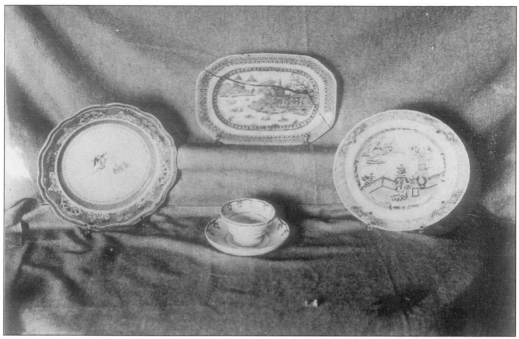

Incomplete Collection of White House China Used by President George Washington. Washington served from 1789 to 1797 as the country's first president. He then retired to his home in Mount Vernon, Virginia.

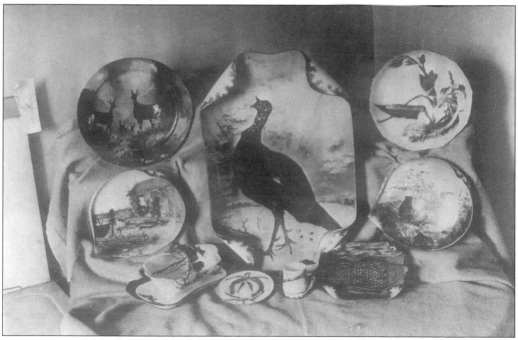

President Rutherford B. Hayes's Wildlife Pattern. Hayes, the 19th president of the United States, who served from 1877 to 1881, was delighted with this unusual wildlife pattern for his official White House china. Incidentally, Hayes was responsible for creating the first seal of the president, although it didn't become official until 1945 under President Harry S. Truman.

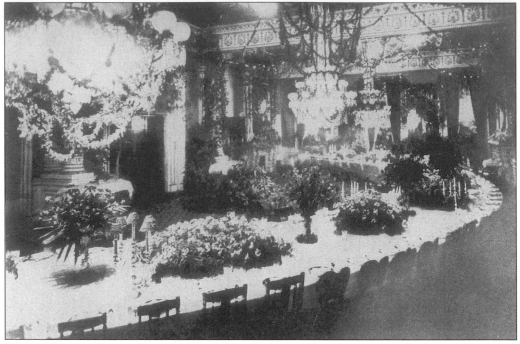

Site 8: The East Room. In 1803 this "Public Audience Chamber," originally designed by James Hoban, was "entirely unfinished, the [ceiling] has given way," according to Benjamin Latrobe in his new plan for the President's House. Little is known of the furnishings before the fire of 1814, but later the room was simply furnished with 4 sofas and 24 chairs. Over the years, the room of the State Dinner, the Presidential News Conference, and State Funerals from Lincoln to Kennedy, was furnished in the style of the day, whether simple Federal style or the crowded Victorian style as the above photo shows. Today, the East Room, with its parquet floor and plaster decorations, is in keeping with the spirit of the early 19th century. The large portrait of George Washington was saved by Dolley Madison as she fled the White House in 1814; it is the only object here that dates to before 1814. A portrait of Martha Washington is to your left.

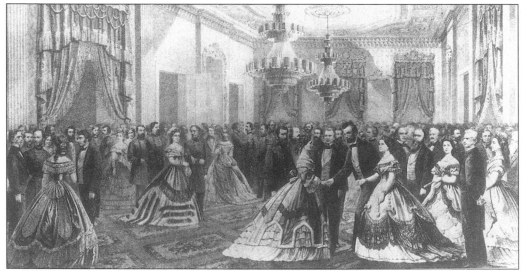

A Reception in the East Room with President Abraham Lincoln, c. Early 1860s.

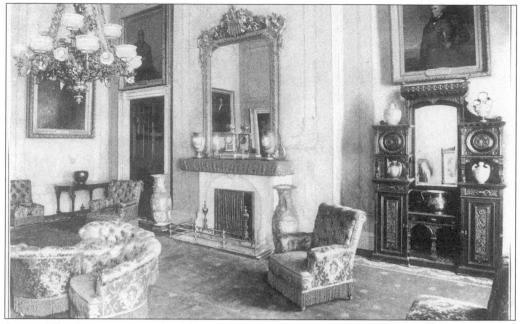

Site 9: The Green Room. This fashionable 18th-century parlor (the original Common Dining Room), decorated in the American Federal style, would make Jefferson comfortable. Moss-green watered silk material was added in 1962 to enhance the 18th-century furnishings. The painting of Benjamin Franklin above the fireplace today is by David Martin. The French Louis XVI armchair you see at the desk is believed to have been used by George Washington while in the Executive Mansion in Philadelphia. The fireplace mantel is only one of two fireplaces original to the restored White House of 1817 (the second is in a second-floor bedroom). Both of these photos are undated, but both show a different view of this room over the past 100 years.

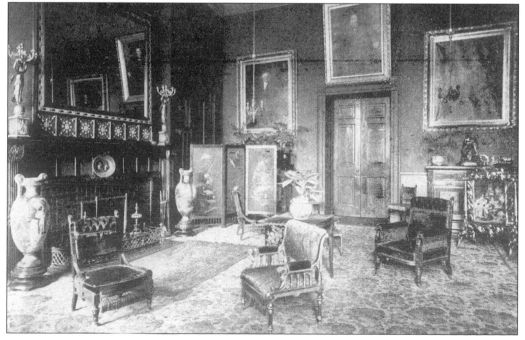

Site 10: The Blue Room. Designed by James Hoban as an "elliptical saloon," this space serves very well as the reception room of the White House. President Martin Van Buren was the first to use blue upholstery on the furniture in 1837, and it has become the central color scheme ever since. In 1962, the Blue Room was redecorated to enhance the collection of Monroe furnishings that included a pier table under the portrait of George Washington. The French gilt bronze and crystal chandelier is a copy of the authentic Monroe chandelier of 1817, and the Minerva Clock is one of the original furnishings bought by Monroe in 1817. Finally, consider the magnificent, unobstructed view of the Jefferson Memorial and the South Lawn from the large south windows.

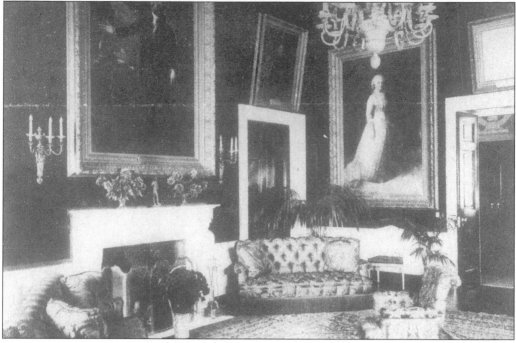

Site 11: The Red Room. Throughout the years, this room has served as a waiting room or sitting room. Today, it is decorated in the Empire style of 1810–1830 with red cerise silk bordered in gold providing the central color scheme. The furniture is French and American workmanship, a style not unlike that found in the early-19th-century White House. An inkwell inscribed "T. Jefferson, 1804" (sometimes displayed here) is the only Thomas Jefferson piece in the White House. The portraits are of Presidents Wilson and Taft, as well as Alexander Hamilton and John Marshall. Again, these photos are undated, but the photo above is definitely of the Victorian era, while the one below may be earlier.

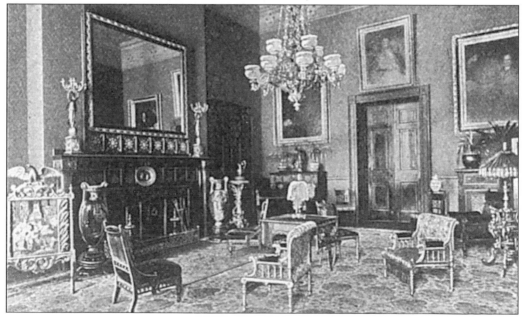

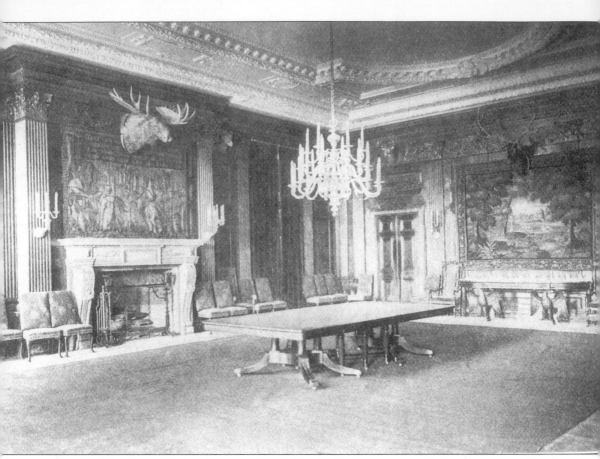

Site 12: The State Dining Room, c. 1901. Originally this was a small dining room used by the president for more intimate dinners. However, things change, and a much larger room was eventually needed to accommodate larger numbers of guests. So, in the renovation of 1903, a west staircase was removed [see the floor plan on page 10 and the photo on page 25] and part of the central corridor was incorporated to form the new, much larger State Dining Room. The furniture is Queen Anne style. The buffalo heads carved into the fireplace mantel were to have been lions' heads but were changed by Theodore Roosevelt to reflect a more native American animal.

The President's Private Staircase. This staircase led to the offices and living quarters on the second floor. After the 1903 renovation, these staircases were removed and the space became part of the State Dining Room.

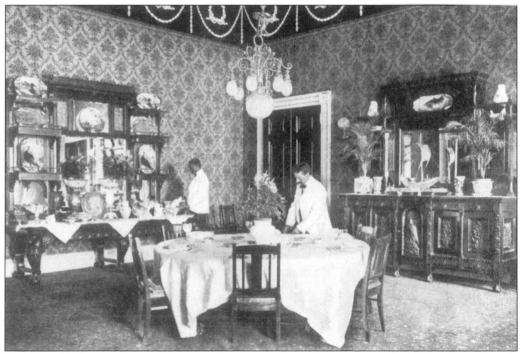

The Family Dining Room. This is a photo, probably taken in the early 1900s, of the Family Dining Room located just across the hall from the State Dining Room. It is not part of the public tour, but this image provides a glimpse into the private areas of the White House.

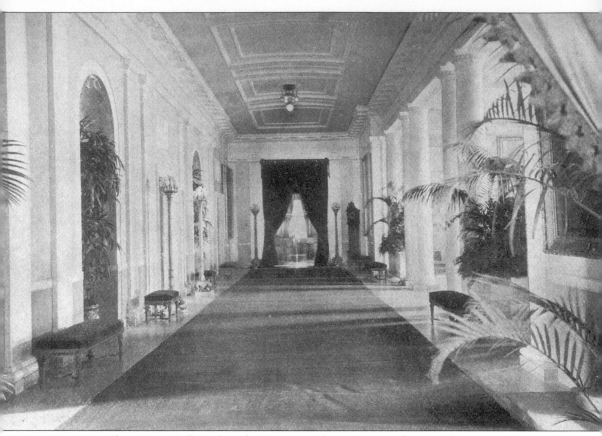

Site 13: The Cross Hall. Before the Reagan Administration, the president emerged into the East Room for a news conference from the side of the room. President Ronald Reagan began the custom of walking through the Cross Hall to enter the press conference in the East Room. This is one of the few rooms in the White House not dramatically altered since it was first designed by James Hoban in 1791. Today, the hall is lit by two 18th-century cut-glass chandeliers and features a red carpet over marble floors installed in the 1948–1952 renovation. The photo above was taken immediately following the 1903 renovation.

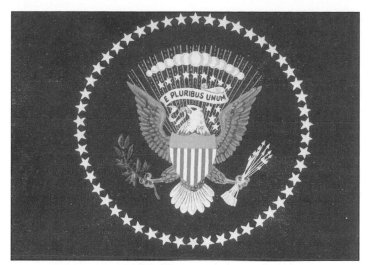

Presidential Flag.

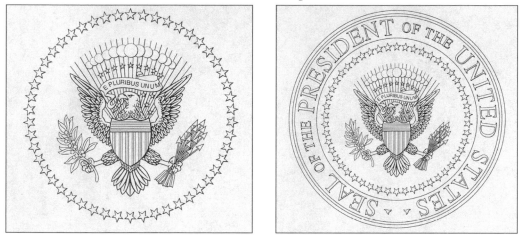

Presidential Coat-of-Arms. Presidential Seal.

Site 13: Flags Flanking the Blue Room. On the left side as you face the Blue Room is the flag of the United States with its 13 stripes of alternating red and white (for the original colonies) with 50 white stars (one for each state in the Union) on a blue canton. Francis Scott Key wrote the "Star-Spangled Banner," our national anthem, in 1814. On the right is the flag of the president of the United States.

Before 1945, there was no official presidential seal. Seals for the president have existed since at least 1845, but none were ever used in an official capacity. The presidential flag has existed since 1865 but only as a military color to denote the president as commander-in-chief. In World War II, the first five-star general was created. Since the presidential flag at the time featured one white star in each corner of a dark blue flag, President Franklin Roosevelt felt that the general outranked the president. He authorized a change in the seal but died before its completion. The new president, Harry S. Truman, modified the design somewhat to include 48 stars, one for each state, placed in a circle surrounding the presidential eagle. It was adopted by an Executive Order on October 25, 1945, the first time a presidential seal was made official. Above the doorway is a somewhat imperfect plaster rendering of the Seal of the President (the gold band between the stars and the eagle is incorrect).

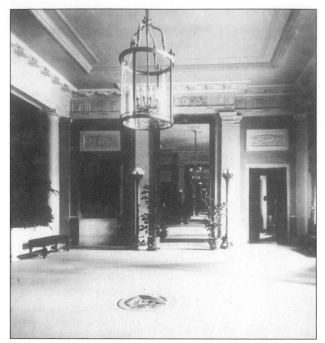

Site 14: The Entrance Hall.
Simply furnished, this space's most striking feature is the piano that sometimes sits here (or in the East Room). Large gold-painted eagles hold up the piano that Presidents Truman and Nixon played occasionally during their time at the White House. The staircase to the right leads to the First Family Residence, where the president's office was located until 1903 (this area is closed to the public). On the floor is a bronze stylized version of an early presidential seal designed by sculptor Philip Martiny but never officially adopted. It was removed during the 1950 renovation and was installed above the Diplomatic Reception Room.

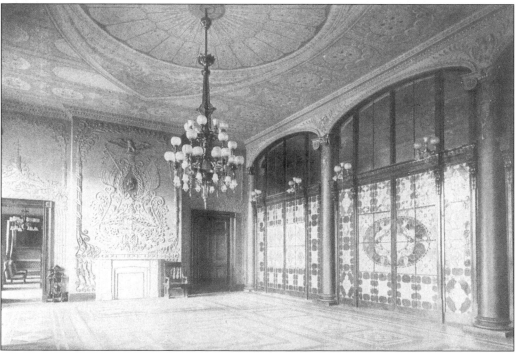

The Entrance Hall. This is what the same area looked like before the 1903 renovation. It included a Tiffany stained-glass window that, when closed, kept the rest of the first floor warm in winter. The dates inlaid in bronze refer to the laying of the original cornerstone in "1792," "1817" is the year the White House was reoccupied after the burning of 1814, "1902" refers to the first major renovation under President Theodore Roosevelt, and "1952" commemorates the second, most complete renovation under President Harry S. Truman.

Site 15: The North Portico, c. 1890. The ionic columns were added only in 1829. It is from the base of these columns that President Lincoln would review the Union Army as it paraded before the White House. From here, the outgoing president shares a ride with the incoming president to the inauguration at the Capitol. Look up at the carvings above the front doors. Nearly two centuries of paint was removed to reveal plaster molding as sharp as the day it was carved. From this unique vantage point, look past the front lawn and the fountain toward Lafayette Square and recite the prayer of President John Adams: "I Pray Heaven to Bestow the Best of Blessings on THIS HOUSE and on All that shall hereafter Inhabit it. May none but Honest and Wise Men ever rule under this Roof."

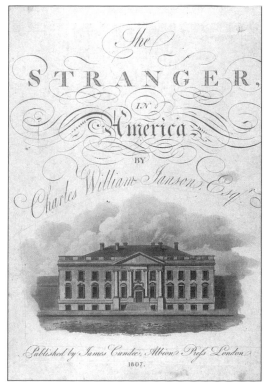

The North Portico Featured in an 1807 Book Frontispiece.

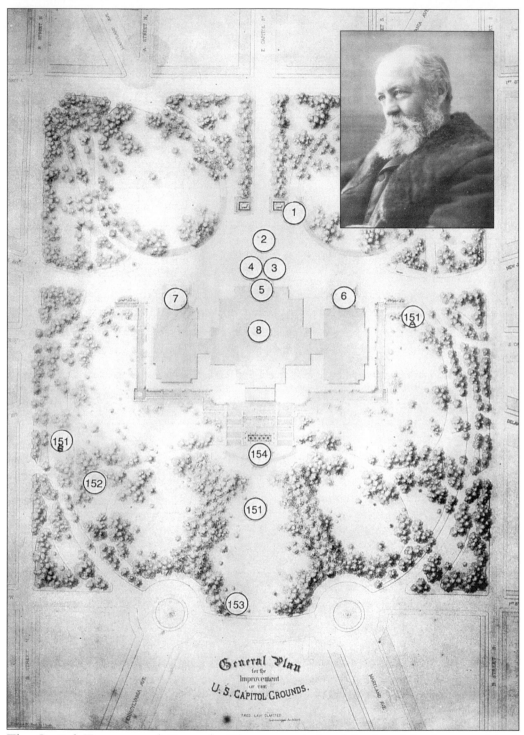

The Capitol Terraces and Grounds. These were designed by famed landscape architect Frederick Law Olmsted (inset) in 1874.

TOUR B
INSIDE THE UNITED STATES CAPITOL

"Here, sir, the people govern."
—Alexander Hamilton

In 1792 William Thornton won the national competition to design the Capitol of the United States, which would house the bicameral legislative branch. However, by November 1800, only the North Wing was completed (where the small Senate Rotunda is located today) and the U.S. Senate, the House of Representatives, the Library of Congress, the Circuit Court, and the Supreme Court all moved in together. In 1801 the House moved to a temporary wooden building on the site of the current House, but by 1804, tired of working in "The Oven," as it was called, the House returned to its original quarters. It was not until 1807 that the House would move into the South Wing, thereby separating itself from the Senate.

On August 24, 1814, along with the White House, the Capitol was nearly destroyed by fire and an invading force of British regulars during the War of 1812. It would be five years later, in 1819, before the North and South Wings would be ready for reoccupation by Congress.

By 1825 the first dome of wood, brick, and copper was finally completed and joined the two separate wings. But by 1850 more space was needed, and Thomas U. Walter, a prominent Philadelphia architect, was appointed in 1851 by President Millard Fillmore to expand the Capitol and provide larger, more permanent chambers for the House and Senate. These chambers were completed in 1857 and 1859, respectively. But it was Walter's cast-iron dome, completed in 1865, that makes the U.S. Capitol the enduring landmark that it is today. There have been other expansions of the Capitol—in 1904 and as late as 1962—but its majesty endures.

Site 1: Balustrades and Lanterns. Encircling the Capitol is a low red granite balustrade, or wall, that extends along the East Front (facing the Library of Congress). On the West Front (facing the Mall), the balustrade is sandstone on top and Ohio stone at the base. The smaller lanterns of the East Front were installed in 1875 and the larger lanterns of the West Front in 1879. Each lantern is iron with copper fittings at the top and glass and was created by the Mitchell and Vance Company of New York City from designs by Frederick Law Olmsted.

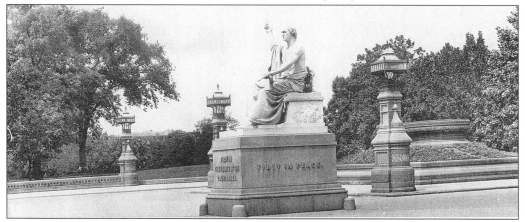

Site 2: Greenough's Washington. Now what could sculptor Horatio Greenough have been thinking when he created George Washington? Knowing that Washington was a demi-god to his countrymen was one thing, but to actually create him in that style in marble—bare-chested and virtually without proper clothing—for a public statue was something else entirely. It was quite shocking to those who attended the unveiling in 1833. Originally installed in the Rotunda of the Capitol in 1841, the stature was moved to the East Front in 1844. It remained outside until it was removed from its base and transferred to the Smithsonian Institution Castle in 1908. When the Smithsonian opened its American History Museum in 1964, the statue was moved there for permanent display.

Site 3: *Discovery of America.* This statue grouping, placed on the empty granite block to the left of the central staircase, shows Christopher Columbus with a round Earth in his hand (not a flat one). Created in marble by sculptor Luigi Persico in 1844, this statue stood nearly 16 feet tall. During the extension of the East Front of the Capitol in 1958, both this piece and the one pictured below were removed and placed in storage. Apparently, they were both so deteriorated that they could not be repaired.

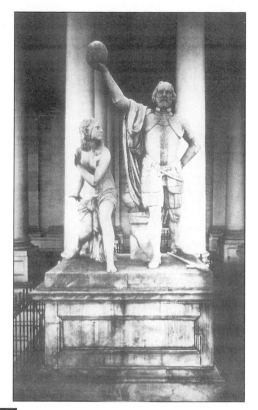

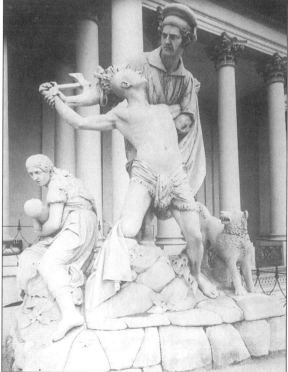

Site 4: *Rescue.* This was the second statue grouping to grace the central staircase of the East Front of the U.S. Capitol. The marble statue was created by sculptor Horatio Greenough and purchased by Congress in 1837, although it was not placed here until 1853. Greenough also sculpted the statue of George Washington that once stood in the East Plaza. This sculpture, which stood nearly 12 feet tall, was also removed and stored during the extension of the East Front in 1958.

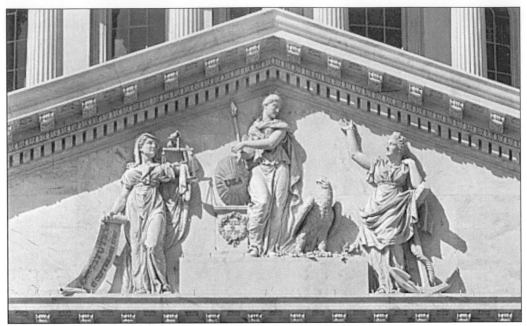

Site 5: *The Genius of America.* From 1825 to 1828, Luigi Persico, who also sculpted the *Discovery of America* (page 33), created the original trio of allegorical figures in sandstone within the central pediment in the East Front. "America" is the central figure holding a shield inscribed with "USA" and resting on a base inscribed "July 4, 1776." On the left is "Justice," who holds a scroll which reads "Constitution, 17 September 1787," and on the right is an eagle and "Hope," who rests her arm on an anchor. Each figure is 9 feet high. The original sandstone figures were removed during the East Front extension and replaced in 1959–1960 with the same figures carved in Georgia marble by Bruno Mankowski from plaster models of the originals. The entire pediment is 81 feet, 6 inches long.

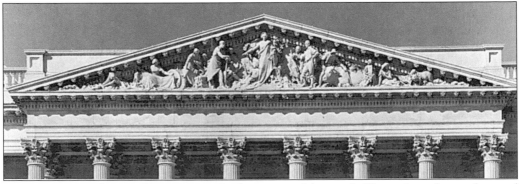

Site 6: *The Apotheosis of Democracy.* In the center of this work, "Peace," in a breastplate and coat of mail, stands in front of an olive tree intending to protect "Genius," who sits at her feet. To the left are allegorical figures representing "Industry" and to the right are figures representing "Agriculture." On either end of the pediment are waves of water representing the Atlantic and the Pacific Oceans and symbolizing the vastness of the United States. The sculptor of this piece was Paul Wayland Bartlett; the Piccirilli Brothers of New York City carved the figures from Georgia marble in 1914–1916. The total length of the sculpture is 60 feet and "Peace" is the tallest figure at 12 feet.

34

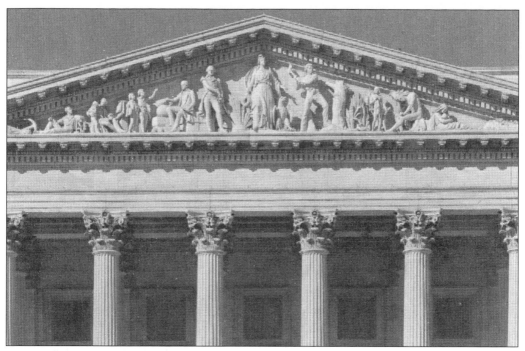

Site 7: *Progress of Civilization.* "America" returns as the centerpiece of this sculpture group, erected in 1863. Each figure was separately carved from Massachusetts marble right here at the Capitol from 1855–1859, although the book *Art in the United States Capitol* does not say by whom. On the right, a woodsman, a hunter, a Native-American chief, and a Native-American mother and child represent the early days in this country. On the left, a soldier, a merchant, two children, a schoolmaster and student, and a mechanic represent progress. On the far right, wheat, symbolizing fertility, and an anchor, symbolizing hope, contrast with the grave of a Native American on the far right. The center figure measures 12 feet high, and the entire sculpture measures 60 feet long.

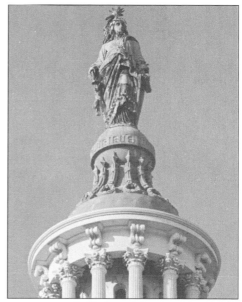

Site 8: Statue of *Freedom.* The statue of *Freedom*, atop the Capitol dome, is the largest statue in Washington, D.C., with a height of 19.6 feet. It stands 288 feet above the East Front plaza. Sculptor Thomas Crawford completed the plaster model in 1857 [see it at Site 150], and Clark Mills of Washington, D.C., cast the final bronze form in 1859. Secretary of War Jefferson Davis suggested the helmet encircled by stars instead of Crawford's Liberty Cap to show "endless existence and heavenly birth." "Freedom" stands on a cast-iron globe that is 7 feet in diameter to symbolize her vigilance over the world; she weighs a total of 14,985 pounds. The statue was placed atop the completed cast-iron dome on December 2, 1863. It was cleaned and repaired in 1993.

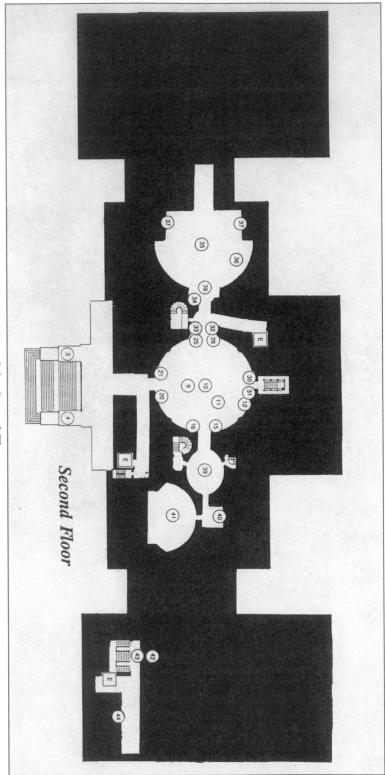

A Map of the Second-Floor.

Second Floor

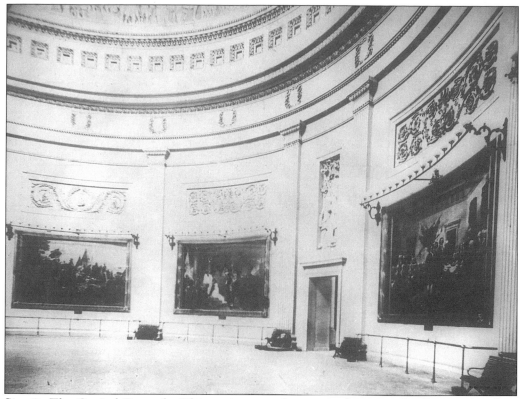

Site 9: The Capitol Rotunda. This entire central cast-iron dome was finally completed on December 2, 1863, during the middle of the Civil War, from a design by Thomas U. Walter. Its completion gave hope and encouragement to the Union troops that their country would survive. At the time, the dome cost nearly $1 million to complete its series of iron trusses, bolts, and girders that support nearly 9 million pounds. Actually, the dome is composed of two shells, one over the other. The inside dome has a base diameter of 96 feet, and the exterior height of the dome is 288 feet from the East Front ground level (including the statue of *Freedom*). Today, the Rotunda serves as the focal point of the U.S. Capitol. Starting at the white marble stone in the center of the Rotunda where Presidents Garfield, McKinley, Lincoln, Kennedy, and others have lain in state, the history of America can be told in the Capitol's paintings, statues, the frieze, and other historic artifacts.

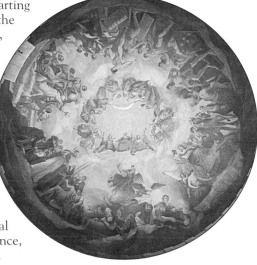

Site 10: *The Apotheothis of Washington.* Directly above you is an allegorical glorification of George Washington as a god. Painted by Constantino Brumidi in 1865 from scaffolding 180 feet above the floor, the work covers 4,664 square feet. The inner circle of maidens represent the 13 original states. The outer circle represents war, science, marine, commerce, mechanics, and agriculture.

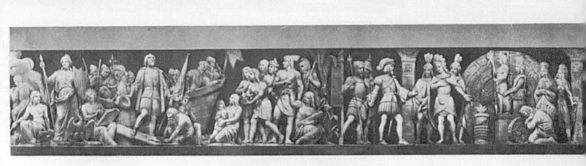

America in History Landing of Columbus, 1492 Entry of Cortez into the Halls of Montezuma, 1521

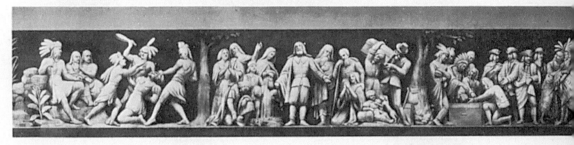

Pocahontas Saving Life of Capt. John Smith, 1607 Landing of Pilgrims at Plymouth, Mass., 1620 Penn's Treaty With the Indians,

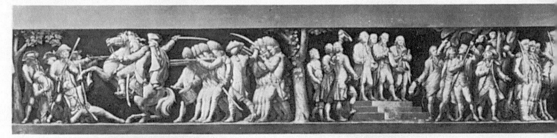

Battle of Lexington, 1775 Reading of the Declaration of Independence, 1776 Surrender

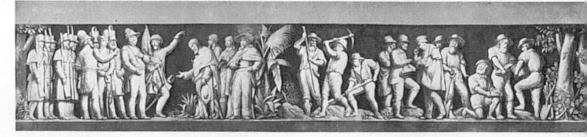

Entry of General Scott into the City of Mexico, 1847 Discovery of Gold in California, 1848

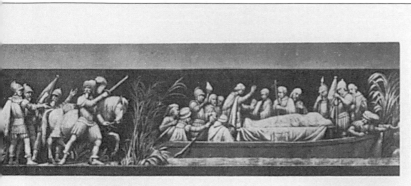

arro's Conquest of Peru, 1533 · Midnight Burial of De Soto in the Mississippi, 1542

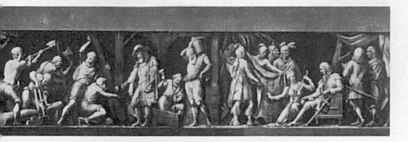

Colonization of New England · Peace Between Governor Oglethorpe and the Indians, 1732

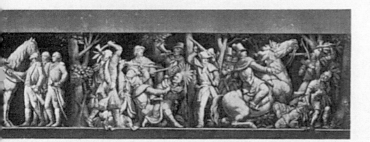

Yorktown, 1781 · Death of Tecumseh at the Battle of Thames, 1813

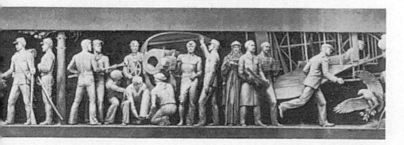

ar, 1865 · The Spanish-American War, 1898 · Birth of Aviation in the United States, 1903

Site 11: The Rotunda Frieze. Located 58 feet above the floor of the Rotunda, measuring 300 feet in circumference and 8.3 feet high, is a series of scenes depicting the history of the United States from the landing of Columbus in 1492 to the birth of aviation in 1903. Constantino Brumidi created the first six scenes and completed about half of the seventh ("Penn's Treaty with the Indians") before his death in 1880. Filippo Costaggini continued the work through the "Discovery of Gold in California," using Brumidi's designs. Allyn Cox completed the last three scenes from 1950 through 1953.

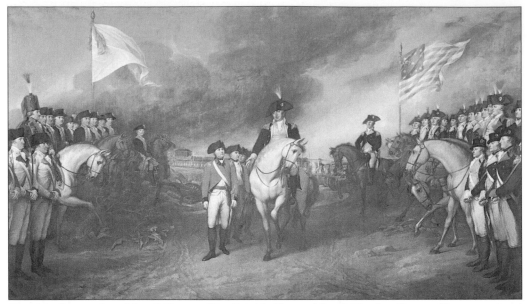

Site 12: *Surrender of Lord Cornwallis.* British General Lord Charles Cornwallis surrendered to the "contemptible and undisciplined rabble" he called the Colonial Army at Yorktown, near the Virginia port of Jamestown on October 19, 1781. His army was surrounded by the French and Americans on land while the French fleet kept his reinforcements from arriving. The surrender of Cornwallis effectively confirmed the independence on the American colonies. John Trumbull captures George Washington on horseback near the American flag on the right while General Benjamin Lincoln, also on horseback, accepts the surrender of the British in the center. Cornwallis is not pictured. The French Army and Navy are on the left. The painting was purchased on November 13, 1820.

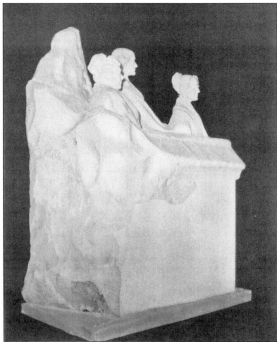

Site 13: Portrait Monument, Memorial to the Pioneers of the Women's Suffrage Movement. Leaders of the movement to grant women the right to vote are carved in this 8-ton block of marble, deliberately left unfinished when it was sculpted by Adelaide Johnson in 1921 to include future honorees. From left to right, Elizabeth Cady Stanton, Susan B. Anthony, and Lucretia Mott all helped organize the first women's rights convention in Seneca Falls, New York, in July 1848, formally launching the women's movement in the United States. Each woman has a long history of activism in the women's movement and, in the case of Lucretia Mott, the anti-slavery movement as well. Women finally received the right to vote with the adoption of the 19th amendment of the U.S. Constitution in 1920—144 years after American independence.

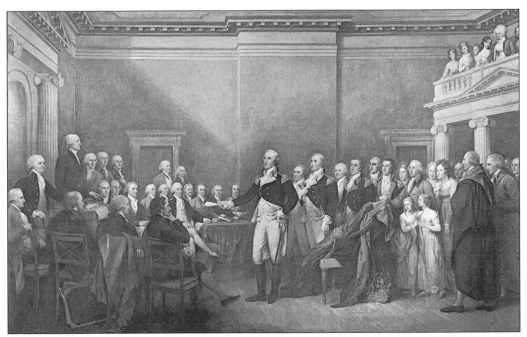

Site 14: *General George Washington Resigning His Commission.* Painter John Trumbull captures a very moving ceremony before Congress on December 23, 1783, as George Washington returns his original commission as commander-in-chief of the Continental Army to the President of Congress Thomas Mifflin. Washington then left for Mount Vernon but returned to federal service as the first president of the United States under the new Constitution in 1789. This painting was purchased on December 24, 1824.

Site 15: James A. Garfield. Garfield was the president of Hiram College in Ohio from 1856 to 1861, and then served as a congressman from Ohio from 1863 until his election to the presidency in 1880. During the Civil War, Garfield last served as chief of staff for the Army of the Cumberland under General William Rosecrans. During the political campaign of 1880, Garfield was actually elected as a U.S. senator from Ohio and as president, but chose to take office as the 20th President of the United States. Garfield was assassinated by Charles Guiteau at the Baltimore and Pacific Railroad Depot (now the site of the National Gallery of Art) in Washington, D.C., on July 2, 1881, and died two months later. He was 50 years old. This marble statue was sculpted by Charles H. Niehaus in 1884–1885, and it was placed in the Rotunda in 1886.

Site 16: Andrew Jackson. "Old Hickory" was born in what is now Tennessee in 1767 and joined in the fighting during the Revolutionary War. Later, he served briefly in the House of Representatives, was elected twice to the United States Senate, and was appointed as a judge of the Tennessee State Supreme Court. His military adventures were his most notable achievements: he was commissioned a major general in 1814, he captured Florida and New Orleans in 1814, he became Florida's governor in 1821, and he was elected as the seventh president of the United States as a Democrat in 1828 and 1832. Among other things, Jackson was probably the last president to have paid off the national debt. He died in 1845. This bronze statue was sculpted by the husband-and-wife team of Leopold and Belle Kinney Scholz in 1927 and dedicated here in 1928.

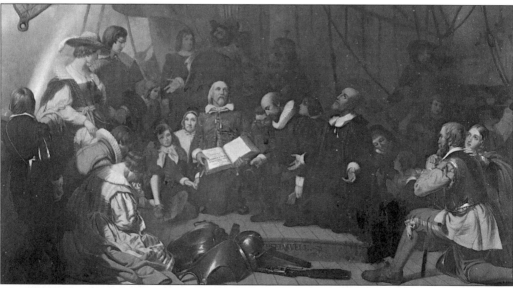

Site 17: *Embarkation of the Pilgrims.* On July 22, 1620, members of the Puritan community left Delft Haven, Holland, for the "New World," where they could practice their religion in peace. This 1843 painting by Robert W. Weir captures the Pilgrims boarding the *Mayflower*. In the center, holding the book, is William Brewster and to his left, with hands upturned, is Governor Carver. Between them, kneeling, is William Bradford. The Mayflower Compact, which guaranteed that the people could vote on their own laws, was signed before landing. In 1621, the Pilgrims held a Thanksgiving celebration to give thanks for surviving another winter; it was the first holiday celebrated by the colonists with their Native-American neighbors and one that persists today on the third Thursday in November.

Site 18: *Magna Carta.* On June 15, 1215, the barons of medieval England forced King John to adhere to the idea that government was subject to the same laws as those it governs. This premise and the Magna Carta they signed helped to create the Constitution of the United States and continues to inspire the constitutions of nations today. This display of pure gold and detailed symbolism was created by Louis Osman of England as a gift to the United States to celebrate its bicentennial on July 4, 1976. The display pedestal is Yorkshire sandstone surmounted by a block of pegmatite, a rare three-billion-year-old volcanic stone from the Outer Hebrides.

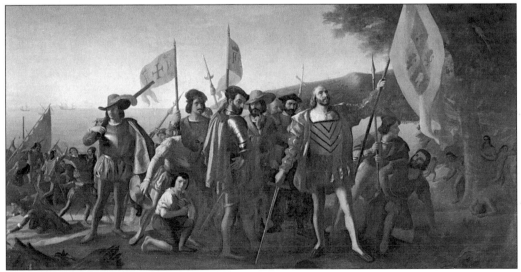

Site 19: *Landing of Columbus.* This painting by John Vanderlyn shows Christopher Columbus landing on the Island of Guanahani, West Indies (now called Watling Island of the Bahamas), which he named San Salvador in August 1492. Columbus thought he had found a western path to the East (meaning Japan and China). Instead, he landed in an area that some believe had already been "discovered" much earlier by the Vikings. This painting was placed in the Rotunda on January 15, 1847. Holding the two flags behind Columbus are brothers Martin Alonzo Pinzon (standing sideways) and Vincent Yannez Pinzon, who piloted the *Pinta* and the *Niña*, respectively. Columbus piloted the *Santa Maria*.

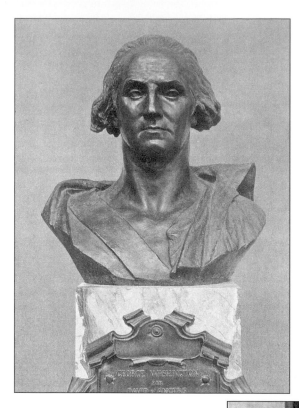

Site 20: George Washington. This bronze bust of the first president of the United States replaced a marble bust that was created by P.J. David d'Angers in 1828 but was destroyed by a fire in the Library of Congress when it was located in the Capitol in 1851. This duplicate was cast from the original model in 1905 and was a gift from the Republic of France. George Washington is a recurring figure in paintings, frescoes, friezes, busts, monuments, and other works of art throughout the Capitol, especially here in the Rotunda. (See Site 26 for a full statue of Washington.)

Site 21: Marquis de Lafayette. Marie Joseph Paul Yves Roch Gilbert du Motier de Lafayette was a major general in the American Army and a close associate of George Washington. Lafayette was instrumental in the defeat of the British and the end of the American Revolution in 1781. After the war, he returned to France and became a member of the National Assembly before the Revolution and twice became a member of the Chamber of Deputies after the Revolution, in 1815 and 1818–1824. This bronze was recast from the original model created by P.J. David d'Angers in 1830 after the first bust was destroyed in the Library of Congress fire in 1851. It was replaced in 1904. Lafayette died in France in 1834 and is remembered fondly in the United States as a French statesman and an American patriot.

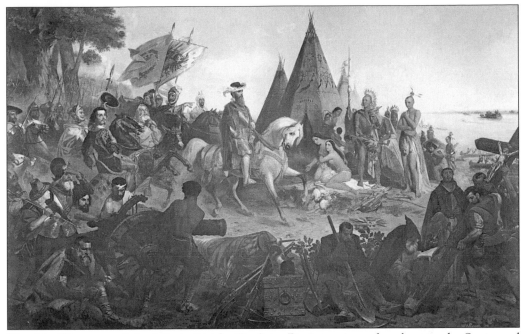

Site 22: *Discovery of the Mississippi by De Soto.* During a time of exploration by Spain and Portugal, Hernando de Soto sailed up to what is now the Mississippi River through Memphis, Tennessee, from 1539 to 1541. Notice the men planting a large cross in lower right of the painting, a Native-American delegation bearing a peace pipe, and the Spanish cavalier just behind de Soto. De Soto died about 1542 while in Louisiana, and his body was buried in the Mississippi in order to prevent its desecration by Native Americans. William H. Powell painted this 12-by-18-foot canvas in 1853, and it was placed in the Rotunda on February 16, 1855.

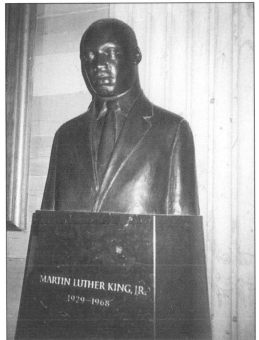

Site 23: Martin Luther King Jr.—Preacher, Reformer, Ordained Baptist Minister, and Nobel Laureate. King's boycott of the bus system of Montgomery, Alabama, to force desegregation in 1956 helped him to found the Southern Christian Leadership Conference the next year to advocate nonviolence and brotherhood during the tumultuous Civil Rights Movement of the 1960s. It also led to his famous "I have a dream" speech at the Lincoln Memorial in Washington, D.C., in August 1963 and to his recognition with the Nobel Peace Prize in 1964. In 1968, at the age of 39, King was assassinated in Memphis, Tennessee.

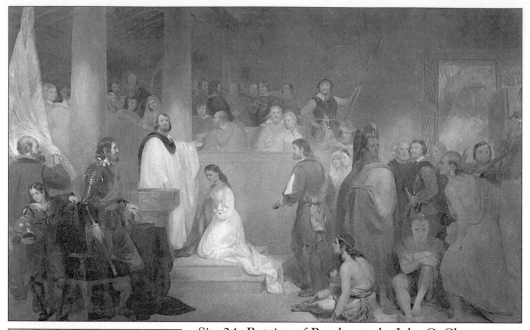

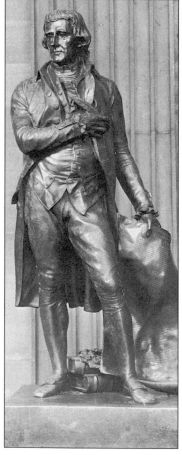

Site 24: *Baptism of Pocahontas* **by John G. Chapman.**
Born Matoaka in 1596, Pocahontas (her nickname) was
the daughter of Algonquin chief Powhatan, the leader of
the Native-American community at Jamestown in 1607. In
this painting, Pocahontas is held captive on a ship by
Captain Samuel Argall in 1613 to force the surrender of
her father. She is shown here being converted to
Christianity at her baptism in 1614 and receiving the
Christian name, Rebecca. She later married John Rolfe, a
colonist. Pocahontas's celebrated rescue of Captain John
Smith from execution in 1607 happened when she was 12
years old, making her much too young for a romance even
then (Walt Disney notwithstanding).

Site 25: Thomas Jefferson. In 1776, Jefferson wrote and,
with the Continental Congress, signed the Declaration of
Independence, granting the colony status as a new nation,
but most notably, the Declaration states "that all men are
created equal." Jefferson was a member of the Virginia
House of Burgesses and the governor of Virginia from 1779
to 1781. He then served as minister to France, secretary of
state, vice president of the United States under John
Adams from 1797 to 1801, and, finally, the third president
of the United States from 1801 through 1809. His founding
of the University of Virginia in 1819 was one of his
proudest accomplishments. Jefferson died on July 4, 1826,
at the age of 83 and on the 50th anniversary of
independence. This bronze statue was sculpted by P.J.
David d'Angers in 1833. It was originally placed near the
North Portico of the White House in 1835 but was
returned here in 1874.

Site 26: George Washington. Antoine Houdon captured a near likeness of the first president of the United States in a 1788 marble sculpture, which now sits in the Virginia Capitol in Richmond. This bronze casting of the original marble statue was commissioned in 1909 and placed in the Rotunda. George Washington was a former surveyor, the first commander-in-chief of the Continental forces, the president of the Constitutional Convention, and the president of the United States in 1789. Washington retired to his home at Mount Vernon in 1797 but returned as commander-in-chief of the army in 1798 to fight the French, if needed. He died in 1799 at Mount Vernon, Virginia, and is forever fondly remembered as the "Father of our Country."

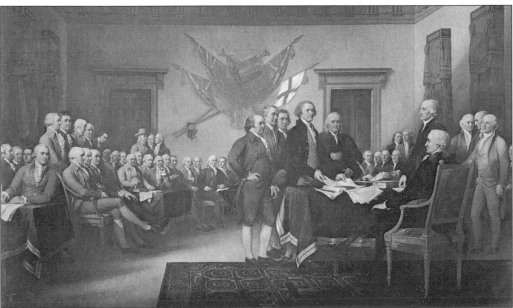

Site 27: *Declaration of Independence.* The Continental Congress deliberated from June 7, 1776, until "The Unanimous Declaration of the 13 United States of America" was finally signed by the president of Congress John Hancock on July 4, 1776, at Independence Hall in Philadelphia, Pennsylvania. The Declaration was really a list of grievances against King George III of Great Britain and declared that the colonies no longer owed him allegiance. The Revolutionary War, though, continued until 1781. There were 56 signers, and John Trumbull, in his painting of 1819, highlighted, at the front table from left to right, John Adams, Roger Sherman, Robert Livingston, Thomas Jefferson, and Benjamin Franklin—the members of the committee that drew up the Declaration. John Hancock is seated behind the table.

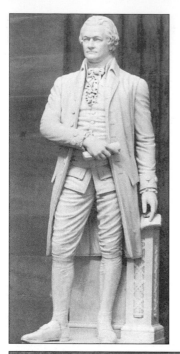

Site 28: Alexander Hamilton. As Washington's aide-de-camp during the Revolutionary War, Hamilton saw much of the future president throughout the conflict. Later he was a member of the Continental Congress and wrote treatises with James Madison and John Jay supporting the adoption of a new Constitution for the *Federalist*. Hamilton was the first secretary of the treasury and helped put the struggling nation on a sound fiscal basis. He died in a duel with former vice president Aaron Burr in 1804. Horatio Stone memorializes Hamilton in this marble statue in 1868. It was placed in the Rotunda that same year.

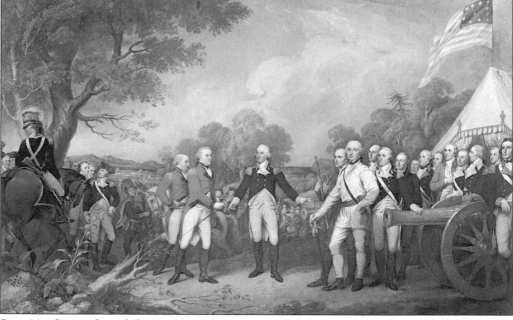

Site 29: *Surrender of General Burgoyne.* On October 17, 1777, General John Burgoyne surrendered his army of British regulars to General Horatio Gates of the Continental Army at Saratoga, New York. It was "a day famous in the annuals of America" as written by British Lieutenant William Digby. It was truly one of the best and brightest victories for the colonial forces. The victory foreshadowed the final victory for independence almost exactly four years later on October 19, 1781, at Yorktown. John Trumbull again shows his talents in this 1822 painting that shows Gates accepting the sword of Burgoyne, who is surrounded on all sides by the American forces.

Site 30: Ulysses S. Grant. Born Hiram Ulysses Grant in 1822, a congressman's error changed his name to Ulysses S. Grant when he applied to West Point. This most famous of generals would actually resign from the military after the Mexican War in 1854 to go into business. The Civil War returned him to military service as a colonel of Illinois volunteers. He rose in rank to commander of all the armies of the United States in 1864 and accepted the surrender of Confederate forces headed by General Robert E. Lee at Appomattox Court House on April 9, 1865. Grant was elected the 18th president of the United States in 1868 and 1872. He died in New York City in 1885. Franklin Simmons created this marble statue in 1899 as a gift from the Grand Army of the Republic.

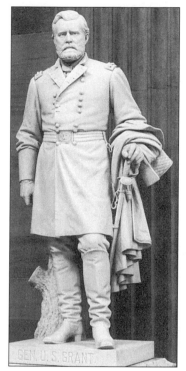

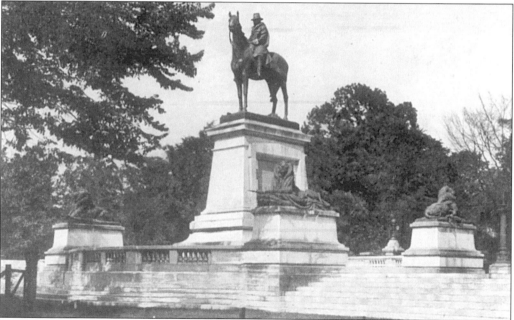

The Grant Memorial in Washington, D.C., was created by Henry Schrady over a 20-year period and features Grant in uniform on horseback standing 17.2 feet high. The statue weighs 10,700 pounds and rests on a 22.5-foot-high marble pedestal, which was completed in 1922. The two other statue groups are *Artillery*, completed in 1912, and *Cavalry*, completed in 1916. Schrady died of overwork only two weeks before the piece's final dedication. Taken together, the statue group is the largest equestrian statue in the United States.

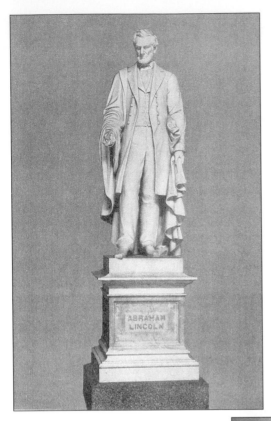

Site 31: Abraham Lincoln. This marble statue of the 16th president of the United States was sculpted by Vinnie Ream in 1870 and purchased for the Rotunda in 1871. Lincoln is credited with keeping the Southern states from seceding during the U.S. Civil War between 1861 and 1865. During the Civil War, he signed the Emancipation Proclamation on January 1, 1863, which effectively freed the slaves in the states that were in rebellion. Later that year, he gave his immortal Gettysburg Address on November 19, 1863. Five days after Lee's surrender at Appomattox on April 14, 1865, Lincoln was shot by actor John Wilkes Booth at Ford's Theater in Washington, D.C. He died the next day at the age of 56.

Site 32: Stephen Austin. Elisabet Ney, herself a native of Austin, Texas, shows her city's namesake as an early colonizer of the Mexican state of Texas in this marble statue completed in 1904. Austin was born in 1793 in Austinville, Virginia, but directed the judicial and military departments for the Mexican state of Texas from 1822 until 1832. He was jailed in Mexico City in 1833 when he called for an independent Texas. The Lone Star Republic of Texas became a reality in 1836, and Austin became its secretary of state. He died that same year. Texas was annexed to the United States in 1845, and Austin is its capital.

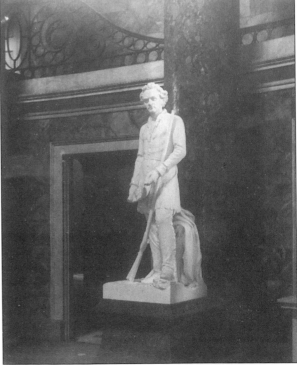

Site 33: John Peter Gabriel Muhlenberg. As the first of three sons to follow in his father's footsteps as a Lutheran clergyman in 1772, John served in the Revolutionary War as a brigadier general, fought with "Mad" Anthony Wayne and Baron von Steuben, and helped win the war in Yorktown in 1781. Later, he became vice president of Pennsylvania in 1785 and a member of the House of Representatives three different times from 1789 to 1801, when he became a senator for less than a year. He returned to Pennsylvania as supervisor of revenue and collector of customs. He died in 1807 at the age of 61. This marble statue was sculpted by Blanche Nevin in 1884 and installed in the Small House Rotunda in 1889.

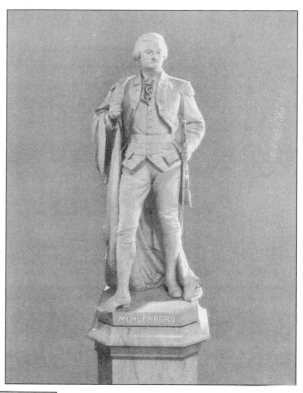

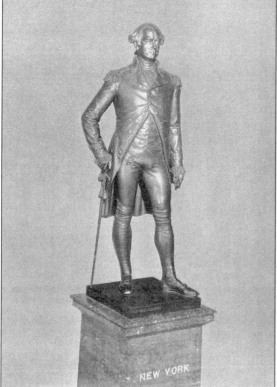

Site 34: George Clinton. Clinton was born in Little Britain, New York, in 1736 and served in the French and Indian War and the Revolutionary War along with his brother James. He later served in the New York Provincial Assembly and Continental Congress before independence. During the Revolutionary War, he was a brigadier general of militia. From 1777 to 1795 he served as the first governor of the state of New York (he served again from 1801 to 1804). He ran for president in 1800 and 1804, but managed to come in second, serving as vice president under both Thomas Jefferson and James Madison from 1805 until Clinton's death in 1812. The statue by H.K. Brown was sculpted in 1873 and placed in the Small House Rotunda that same year.

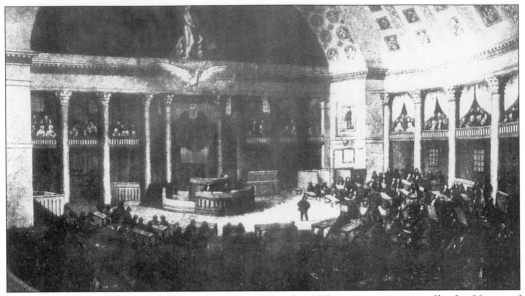

Site 35: The Old House of Representatives Chamber. This area was originally the House of Representatives from 1807 to 1857, when it convened in its present location on the second floor. Henry Clay, John Calhoun, Daniel Webster, and so many historical figures of the early 19th century served in this chamber. President John Quincy Adams won reelection to the House after his presidency and suffered a stroke on the floor of this chamber on February 21, 1848. He was taken into the adjoining Speakers Office, where he died a short time later (a small bronze plate marks the spot where his desk once stood).

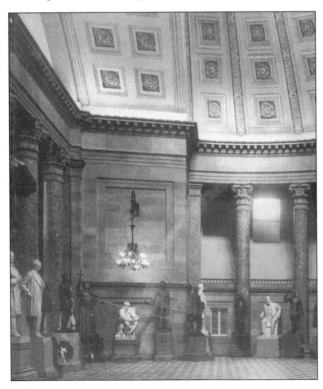

Site 36: Statuary Hall. Today, the Old House Chamber, abandoned for its new wing in 1857, now honors men and women who were "illustrious for their historic renown or for distinguished civic or military services" in their native states. Beginning in 1864, two citizens from each state were honored here (as of 1999 only Nevada, New Mexico, North Dakota, and Wyoming have yet to donate a second statue—for a total of 96 statues). By 1930, statues were moved throughout the Capitol to prevent collapse of the floor due to the enormous additional weight of the bronze and marble statues. This photo is probably c. early 1900s, taken well before the fireplaces and red curtains were added. Try to find all of the bronze plaques showing where the desks of former presidents were located.

Site 37: Fireplaces. The Vermont marble fireplaces were restored in 1974 with carvings of "History" and "Justice" by Francesco Tonelli and other carvings by Renzo Palmerini and L. Carusi. Above the fireplaces are copies of the Declaration of Independence. As you enter Statuary Hall, the one on the left is the original copper or steel 1818 engraving by John Binns that hung here from 1819 to 1853 and was only recently returned. The one on the right is a copy whose frame was carved by Harold C. Vogel and placed here in 1975, in time for the nation's bicentennial.

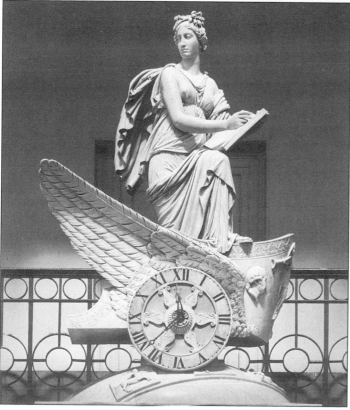

Site 38: Clio, the Muse of History. This was once the official clock of the House of Representatives from 1819 until 1857. Clio is recording history for posterity as she rides in a winged chariot. The clock has been keeping time here since its sculptor, Carlo Franzoni, created this marble time piece in 1819. Clio rests on a globe that shows the signs of the zodiac in relief. The clock works were created by Simon Willard.

53

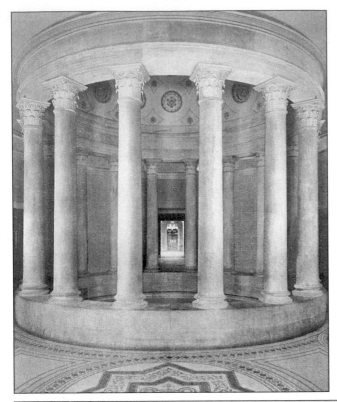

Site 39: The Old Senate Rotunda. Within this area the first session of Congress convened on November 22, 1800. All 106 members of the House met on the second floor, across from the Old Senate Chamber, while the 32 members of the Senate convened on the first floor. The Supreme Court, the Circuit Court, and the Library of Congress soon followed. Naturally, it was quite crowded. This small ornate rotunda replaced an original stairwell that was burned in 1814. Architect of the Capitol Benjamin Latrobe built this replacement to act as a light well and placed a motif of tobacco leaves at the top of each of the 16 columns representing the 16 states in the Union then. (You will visit the upper Rotunda at Site 65 with a better view of these columns.)

Site 40: The Original House Chamber. The House of Representatives originally met here in 1800. Later, to relieve overcrowding, they moved to "The Oven" from 1803 to 1806, a very hot chamber built on or near the current Statuary Hall. It was an oval-shaped, one-story building that was razed shortly thereafter. Then, the House again met in its old quarters here, until it convened in Statuary Hall in 1807 to relieve overcrowding. The House moved to its permanent chamber in 1857, where it continues to meet today.

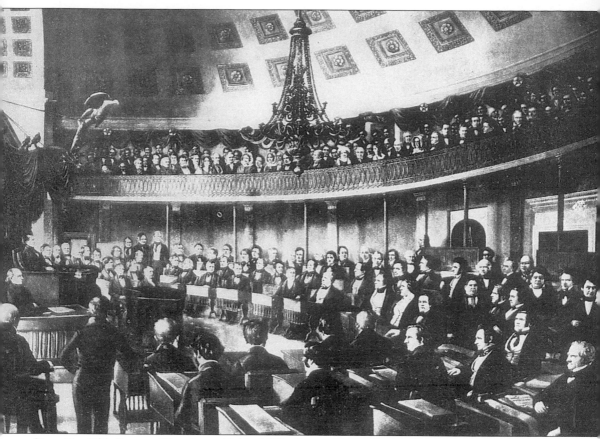

Site 41: Old Senate Chamber, 1810–1859. Beginning with the first 34 members of the Senate, the original Senate Chamber met on the ground floor until repairs to the prematurely decaying walls were needed. Benjamin Latrobe decided during reconstruction to create two floors, in effect creating a two-story structure instead of just one. The new first floor would hold staff offices, the Supreme Court, and the Library of Congress; the second floor would be used as the Senate Chamber. During construction the Senate convened temporarily on the West Wing side until repairs were completed in 1810. The Senate reconvened in this room and used it until 1859. Here the impeachment trial of Associate Justice of the Supreme Court Samuel P. Chase was held in 1804. The Louisiana Purchase was ratified and the peace treaties ending the War of 1812 and the Mexican War were confirmed here as well.

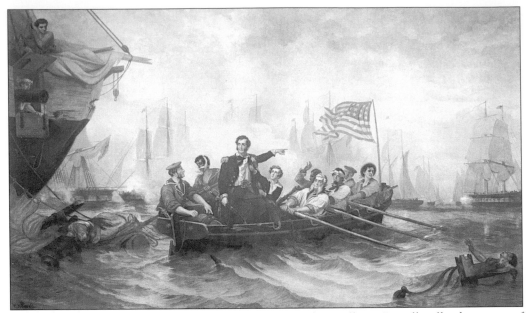

Site 42: *Battle of Lake Erie.* This 1873 painting by William Powell tells the story of Commodore Oliver Hazard Perry's victory over the British in the Battle of Lake Erie during the War of 1812. His famous message—"We have met the enemy and they are ours"—on September 10, 1813, proclaimed an early victory for the U.S. Navy. Here, Perry rows a half-mile to the USS *Niagara* after his flagship, the USS *Lawrence*, was severely damaged. Legend has it that this painting was posed for by Capitol employees. William Powell also painted *Discovery of the Mississippi by De Soto* that hangs in the Capitol Rotunda.

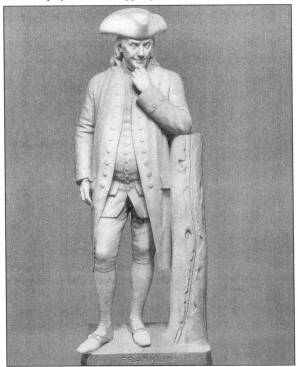

Site 43: Benjamin Franklin. Franklin was a scientist (he experimented with lightning, 1752); an inventor (the Franklin stove, 1744; bifocals, 1748); a philosopher (he wrote *Poor Richard's Almanac*, 1732–1757), a printer (he published the *Pennsylvania Gazette*, 1730–1748), and a writer (many political, religious, etc. articles). He was also a state, continental (where he was part of the committee that wrote the Declaration of Independence in 1776), and constitutional delegate; the founder of the University of Pennsylvania; and the deputy postmaster for the colonies between 1753 and 1774. He negotiated international treaties with France and Great Britain before he died in 1790 at the age of 84. H. Powers captures Franklin at his best in this 1862 marble statue—he's thinking.

Site 44: Senate Reception Room, S-213. Constantino Brumidi began his work in this Senate room in 1858 and painted his last work here in 1872. In 1870 he painted on the south wall a work titled *George Washington in Consultation with Thomas Jefferson* [Secretary of State] *and Alexander Hamilton* [Secretary of the Treasury]. Five medallion portraits of respected senators were added in 1959.

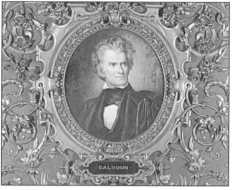

John C. Calhoun of South Carolina
(Senator 1832–1843, 1845–1850)
by Arthur Conrad, 1958.

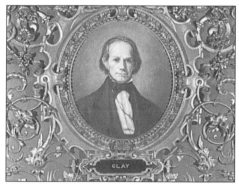

Henry Clay of Kentucky
(Senator 16 years between 1806–1852)
by Allyn Cox, 1958.

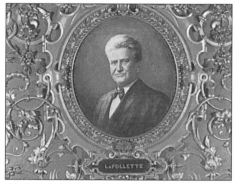

Robert M. La Follette Sr. of Wisconsin
(Senator 1906–1925)
by Chester La Follette, 1958.

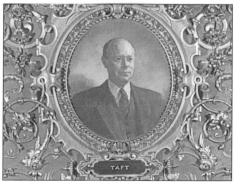

Robert A. Taft of Ohio
(Senator 1939–1953)
by Deane Keller, 1958.

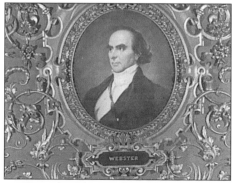

Daniel Webster of Massachusetts
(Senator 1827–1841, 1845–1850)
by Adrian Lamb, 1958.

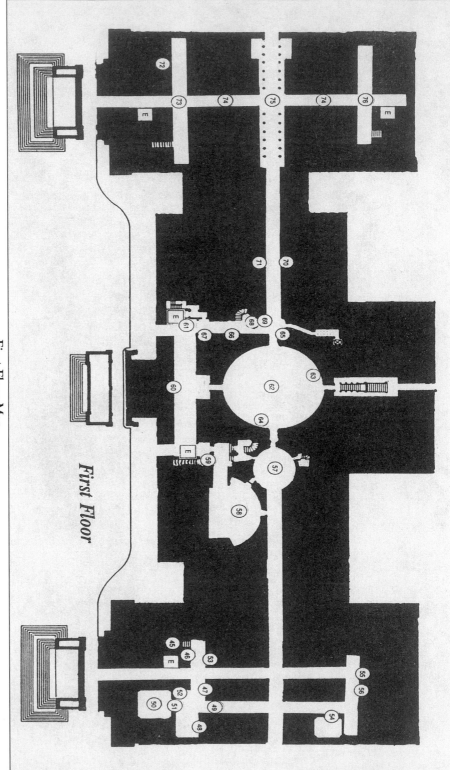

First Floor Map.

First Floor

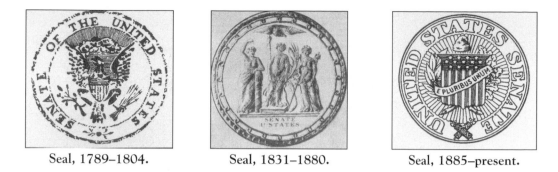

Seal, 1789–1804. Seal, 1831–1880. Seal, 1885–present.

Site 45: Senate Seal in Stained Glass. The power and authority of the United States Senate is embodied in this wonderful stained-glass work by the J. & G.H. Gibson Co. in 1859. It was created from a process known as "triple enameled glass" where the design is painted onto the surface of leaded glass. This seal design dates from 1885, following two earlier versions: one used from 1831 to 1880, the other from 1798 to 1804 (see above). Here, the shield is similar in design to the U.S. Great Seal [see page 67] in that there are 13 stripes and 13 stars (7 red, 6 white), representing the original colonies; the motto "E Pluribus Unum" (translated as "one among many," meaning one nation from many states); on the left of the shield are olive branches and on the right are oak branches. A liberty cap sits atop the shield and rays emanate from behind the shield to signify the burst of a new nation. The seal is used to authenticate documents and is used in resolutions, appointments, and commendations.

Site 46: Public Stairways.
There are four principal public stairways in the House and the Senate. Each are made of "white marble with the balustrade columns and cornices of Tennessee marble with bronze Corinthian capitals," according to Glenn Brown's book, *History of the United States Capitol*, published in 1902. There are other, more elaborate private stairways designed by Thomas U. Walter, architect of the Capitol, 1851–1865, that feature railings of bronze eagles, cherubs, and flowers.

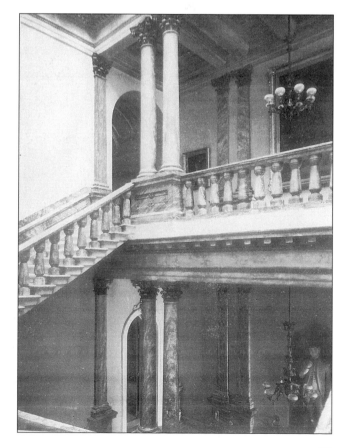

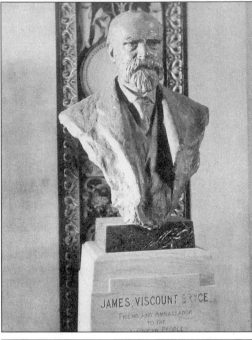

Site 47: James Viscount Bryce. Bryce was Britain's ambassador to the United States from 1907 to 1913, and this bronze statue, created by Sir William Reid Dick, was the gift of Sir Charles Cheers Wakefield, on behalf of the Sulgrave Institution of Great Britain, to the Capitol in 1922. Bryce was born in Ireland to a Scottish family in 1838, became a member of parliament in 1880, and was undersecretary for foreign affairs under Prime Minister William Gladstone in 1886. He was named to the International Court of Justice in 1914. Bryce died in 1922 at the age of 84. Lord Bryce once described Washington, D.C.'s Rock Creek Park as having "nothing comparable in any capital city of Europe."

JAMES VISCOUNT BRYCE
FRIEND AND AMBASSADOR
TO THE
AMERICAN PEOPLE

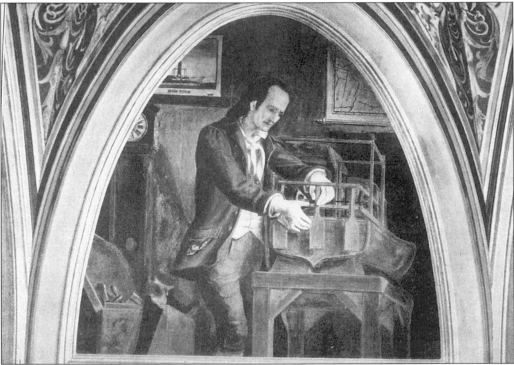

Site 48: John Fitch. Here, Brumidi shows Fitch working on his model of a steamboat in this 1873 painting. Fitch's interest in steamboat design actually began in 1785. On August 22, 1787, he successfully launched his first steamboat on the Delaware River and continued to build them larger and faster until he was granted a patent in 1791. The venture was not commercially successful, however, until Robert Fulton's design in 1807. Fitch died in 1798 when he was 55.

Site 49: Brumidi Corridors. There are actually five corridors here: West, North, Inner, Main, and Patent. This photo was taken about 1900. Over the next few pages, you will see some of the most famous 19th-century Brumidi paintings plus a few 20th-century additions. Pick up a free copy of *The Brumidi Corridors* at the Senate gift shop to view more of them. In all, Brumidi worked in the Capitol for over 25 years. He used tempera, oil, and fresco (painting with earth colors on wet plaster), and his technique, called *trompe l'oeil*, gives each fresco a three-dimensional appearance. You will see a variety of flora, fauna, fruits, birds, and animals along with small portraits, called medallions, of famous patriots such as John Jay, Roger Sherman, and Robert Morris, all signers of the Declaration of Independence. There are also the 12 signs of the zodiac. Happy hunting, and remember, the paintings are art, please don't touch.

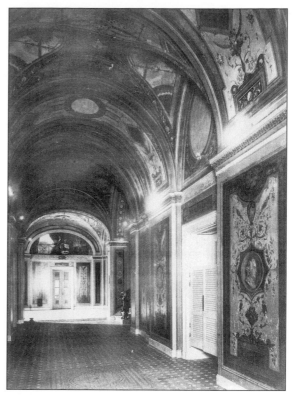

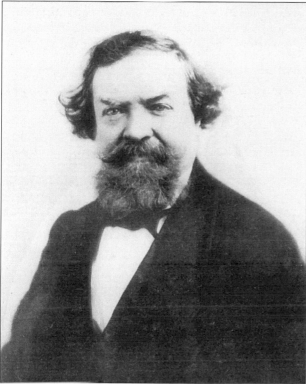

Brumidi. Known as "The Michelangelo of the Capitol," Constantino Brumidi was born in Rome, Italy, in 1805 and came to the United States in 1852. He was hired by Captain (later General) Montgomery Meigs in 1855 to provide classical images and other decorations for the newly expanded Capitol corridors and rooms. Brumidi continued his work for 25 years until he slipped and nearly fell while painting the Rotunda frieze in October 1879. He died on February 19, 1880. He was 75. He is buried in Glenwood Cemetery in Washington, D.C., Site 6, Lot 70.

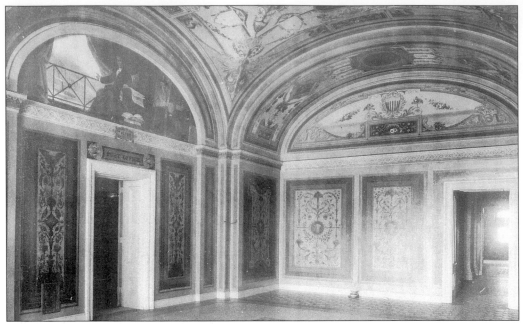

Site 50: Foreign Relations Committee Room, S-116, Patent Corridor. The House of Representatives and the Senate both have committees that deal specifically with relations with other governments and international organizations, but at times their responsibilities differ. The Constitution limits the role of the House to appropriating the money needed to conduct foreign affairs; the Senate approves treaties and nominations of ambassadors. Each holds hearings on national security issues, foreign policy, international economic policy, and other diplomatic issues that arise from time to time. The photo above shows that this room's function has changed over the years. In 1900, when the photo was taken, it was the Post Office Committee room.

Site 51: Robert Fulton (above room S-116, Patent Corridor). This lunette (a style of painting) was completed in 1873 and is the largest one that Constantino Brumidi painted for the Capitol. Here, Brumidi shows Robert Fulton, a former portrait painter, engineer, and inventor, with *Clermont*, the first commercially successful steamboat Fulton perfected in 1807 [see Site 52]. It successfully traveled from New York City to Albany, New York, and back in August 1807. Fulton continued designing steamboats that would be useful in rivers and even designed one adapted for warfare in 1814. He had invented the submarine but could not sell it; he did successfully patent machines to cut marble and to twist hemp into rope. He died in 1815 at the age of 50. This photo is from Glenn Brown's *History of the United States Capitol* of 1900, when this was the Post Office Committee room.

Site 52: John Paul Jones. The original full name of this American Revolutionary War hero was simply John Paul. When he emigrated from Scotland in 1773, he added the last name Jones. In 1779 his flagship *Bonhomme Richard* attacked the British and sank the British ship *Serapis*, during which he was to have said, "I have not yet begun to fight." His own ship sank two days later. After the revolution, Jones served in the Russian navy until 1792, when he died. His remains can be found at the Naval Academy in Annapolis, Maryland. This bust by the celebrated sculptor Antoine Houdon was done from life in 1780 and placed in the U.S. Capitol in 1948.

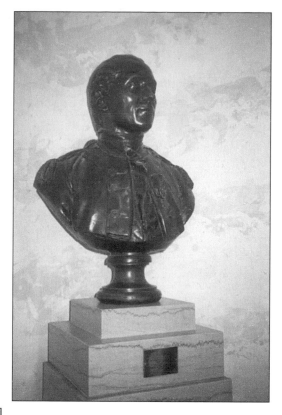

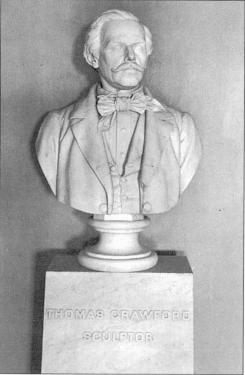

Site 53: Thomas Crawford. An American sculptor and a resident of Rome for most of his life, Crawford contributed a large collection of classical sculptors to the U.S. Capitol, most notably *Freedom* atop the Capitol dome. Born in New York City in 1814, his other designs include the bronze doors; *Washington* in Richmond, Virginia; the pediment of the Senate of the east front; and others. This marble bust is by Tommaso Gagliardi and was acquired by the U.S. Capitol in 1871. Crawford died in 1857 at the age of 43.

Note: Don't forget to see the *Challenger* and *Moon Landing* frescoes above S-120 and S-119. Their images were not available for this publication.

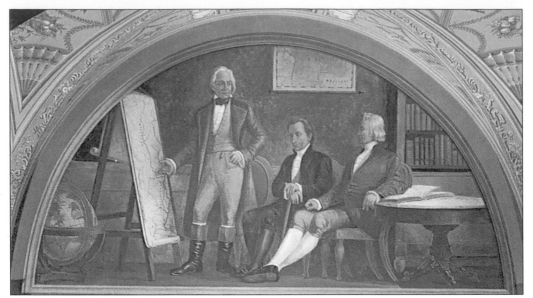

Site 54: *Cession of Louisiana* **(above room S-124, North Corridor).** From left to right, the Marquis Barbe-Marbois, James Monroe, and Robert Livingston negotiate the purchase of Louisiana from France. At the conclusion of the negotiation, Louisiana was purchased from France for $15 million in 1803. Eventually 13 individual states were formed from it: Louisiana, Arkansas, Oklahoma, Montana, Colorado, Kansas, Nebraska, Iowa, Wyoming, Minnesota, North Dakota, South Dakota, and Missouri. This image was painted by Brumidi in 1875.

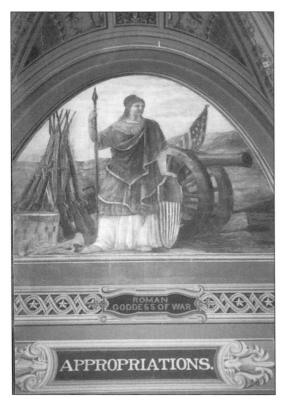

Site 55: *Bellona, the Roman Goddess of War* **(above room S-128, West Corridor).** In 1875, Brumidi also created this wonderful lunette in fresco. Enyo, as she is called in Greek mythology, accompanied Ares, the Greek god of war, and his two sons, Deimos (Fear) and Phobos (Dismay), into constant battle. Actually, Enyo was only a personification of war and had little mythology attached to her. Originally, this room housed the Committee on Military Affairs.

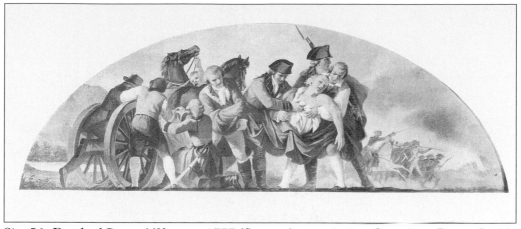

Site 56: *Death of General Wooster, 1777* (Senate Appropriations Committee Room, S-128, West Corridor). The House and the Senate both have committees that determine how to spend tax money every fiscal year, which ends on October 1, under the procedure outlined in the Congressional Budget Act of 1974. After the appropriations process is complete, Congress authorizes the money to be spent as a separate bill. The Constitution provides that all appropriations bills begin in the House of Representatives only. The Senate can only agree or disagree with the House's versions of appropriations. If you have a staff pass, you can see, on the left wall, *Washington at Valley Forge, 1775* and *The Battle of Lexington, 1775*. On the right is *Boston Massacre, 1770* and *Death of General Wooster, 1777*. All were painted by Constantino Brumidi. This room is occasionally open to the public when it is not in use.

Site 57: Small Senate Rotunda. This is the original wing of the first Congress to be held in Washington, D.C., in 1800. Architect Benjamin Latrobe replaced a set of stairs that were originally located here with this small rotunda. Its function was to transmit light and air from a skylight that was originally located above (it was covered over in the early 1900s). At the top of the columns are carved tobacco flowers and leaves, the "money crop" of the early colonies. The crystal chandelier was made about 1925 but was salvaged from the old Capitol Hill Methodist Church in D.C. in 1965 and installed here. It contains about 14,500 crystals and 148 lamps.

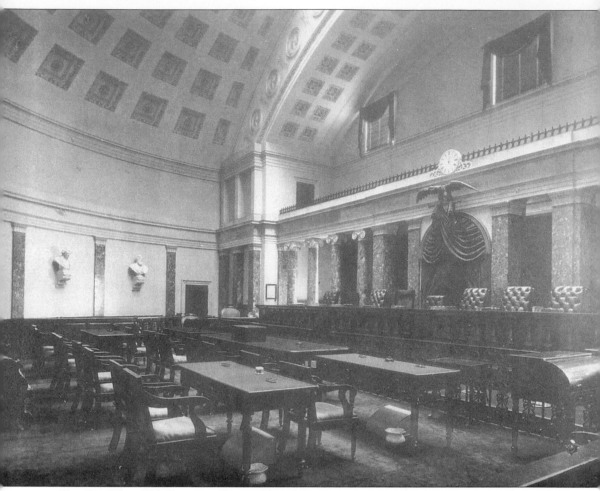

Site 58: The Old Supreme Court Chamber, 1810–1860. The first seven members of the Supreme Court convened here in 1810 after enduring much smaller quarters throughout this wing beginning in 1801. After the burning of the Capitol in 1814, the Court met at the home of clerk Elias Boudinot Caldwell at 206 Pennsylvania Avenue (now the site of the Jefferson Annex of the Library of Congress), and then in a small room in the Capitol until their new chambers were completed in 1819. The great Chief Justice John Marshall, appointed by President Jefferson in 1801, served here until 1835—he was our longest serving chief justice. The Supreme Court moved to the second floor of the Old Senate Chamber in 1860 until President William Howard Taft spearheaded the effort to finally build permanent chambers in 1935. Between 1935 and 1972, the room was used as a law library, a congressional hearing room, and storage space. Funds were allocated for restoration, and it was opened to the public in 1975.

Site 59: Cornerstone of the Capitol. Here, on September 18, 1793, Acting Grand Master of the Maryland's Grand Lodge, George Washington, with silver trowel and marble gavel in hand, together with the Masonic Lodges of Maryland, Virginia, and the District of Columbia, and the Alexandria Volunteer Artillery, laid the cornerstone of the Capitol in an elaborate Masonic ceremony. So far, metal detectors and ground penetrating lasers have been unable to find the exact spot where Washington ceremoniously laid the small silver plate engraved with the calendar year 1789 and the Masonic year 5793.

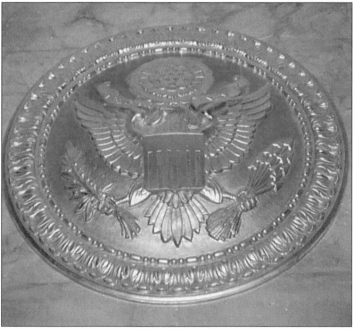

Site 60: The Great Seal of the United States. This gold representation of the official seal of the United States was added here after the East Front extension of 1962. In 1782, Charles Thomson, secretary of Congress, created the first national seal, but in 1885, the seal was redesigned like this. The bald eagle looks toward the olive branches of peace (the arrows of war are to the right) with a "glory" of 13 stars overhead representing the original colonies.

Site 61: Special Memoriam. Nearby, U.S. Capitol police officer Jacob Chestnut and Detective John Gibson were killed by Russell Eugene Weston Jr. on July 24, 1998, as he entered the Capitol through the Law Library Door on your left. Weston was severely injured. Weston recovered, but this former mental patient is still not mentally fit to stand trial for the murders when this book went to press [Nov 99]. See the bronze plaque near the Document Door to your right.

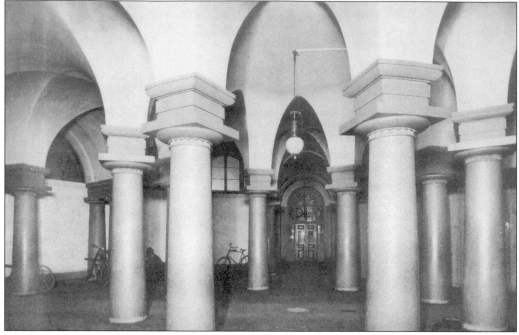

Site 62: The Crypt. You are in one of the oldest areas of the Capitol that became a basement after Charles Bulfinch completed the central section of the Capitol in 1829. A 10-foot hole in the ceiling was to show the final resting place of George Washington [or a statue, depending on who you ask], but it was covered over in 1828. The columns and arches of Aquia Creek sandstone support the weight of the Rotunda above. The white compass stone in the center is the zero point from which all of Washington's streets are numbered and lettered. Today, the Crypt is used to tell the history of the US Capitol and features architectural and historical displays. The elaborate black draped catafalque that has been used in official state funerals since Abraham Lincoln is stored just underneath the Crypt [go down the long stairs, turn right, then right again, then up the stairs on your left].

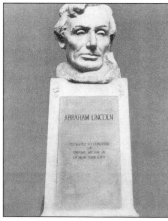 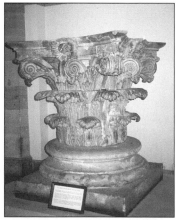

Left: **Site 63: The Bust of Abraham Lincoln.** Mr. Eugene Meyers of New York City presented the bust as a gift to the US Congress as sculpted in marble by Gutzon Borglum in 1908.
Right: **Site 64: A Capitol Corinthian Column.** An original sandstone column cap originally installed in the East Front of the Capitol in 1825 was removed during its extension from 1958 to 1961. New marble columns were added.

Site 65: Lajos Kossuth. The sculptor Csaba Kur created this bronze memorial to the Hungarian freedom fighter Governor Lajos Kossuth in 1987. It was dedicated by Congress and placed here on March 15, 1990. As a member of the Hungarian Diet [national assembly] under the old Austria-Hungarian empire, Kossuth succeeded in having the Diet declare independence. The Diet in turn appointed Kossuth governor of Hungary with almost dictatorial powers in 1848. The insurrection was crushed in 1849, and he resigned and fled to Turkey where he was imprisoned until 1851. He eventually fled to Italy where he died in 1894 at the age of 92 still committed to Hungarian independence.

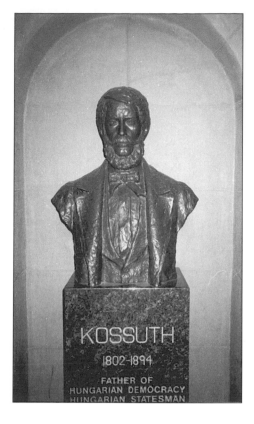

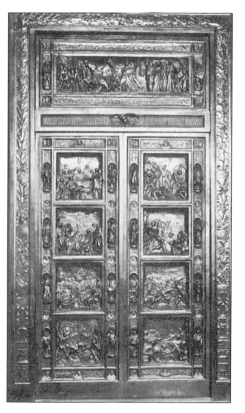

Site 66: The Amateis Bronze Door. This large bronze door was created for the Capitol by the Roman Bronze Works in 1910 based on the design of sculptor Louis Amateis. The door was intended for the new central entrance to the West Front of the Capitol, but the entrance was never constructed. The door was originally moved to the Corcoran Gallery of Art until 1914, then moved to the Smithsonian Institution's Natural History Museum until 1967 when it was stored in the Capitol until permanently displayed here beginning in 1972. The door measures 13.1 feet high by 7.8 feet wide. The posted diagram provides the details to each of the bronze panels.

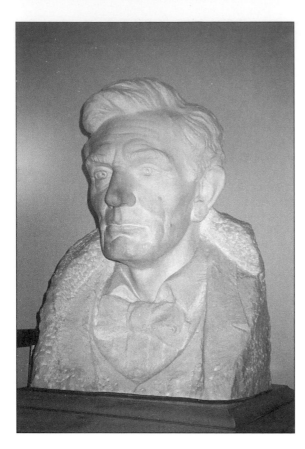

Site 67: "Lincoln the Legislator." This marble bust of Abraham Lincoln, 16th president of the United States, is similar in design to the marble bust sculpted by Gutzon Borglum in 1908 and placed in the Rotunda [see Site 64]. According to the signature carved on the right side, this marble bust was sculpted by Avard Fairbanks in 1984. It portrays Lincoln at the time he served one term as a Whig in the House of Representatives from 1847 to 1849. Fairbanks also carved the oversized head of George Washington on the campus of George Washington University at the Foggy Bottom/GWU Metro station and the angel atop the Mormon Temple in Kensington, Maryland.

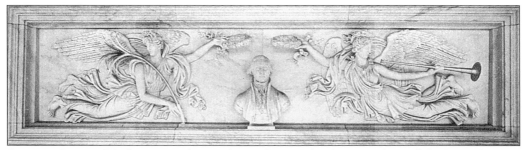

Site 68: George Washington. This sandstone bust of the first president of the United States was originally part of the "Fame and Peace" relief located above the bronze doors of the East Front [the side where visitors wait to enter the Rotunda]. During the extension of the East Front from 1958 to 1960, all of the sandstone figures were reproduced in marble by the Vermont Marble Company and of the originals, by sculptor Antonio Capellano in 1827; the bust of George Washington now resides here.

Site 69: Raul Wallenberg. Ms. Miri Margolin, the Israeli sculptress of this memorial to the Swedish diplomat, created this bronze bust in 1988 and was accepted by Congress for permanent placement here in 1995. This memorial celebrates the heroic actions taken by Wallenberg during the Holocaust year of 1944 when he sheltered nearly 100,000 persecuted Jews under the flag of Sweden in "protected houses" or bribed their way out of the country through forged documents. When the Soviet troops occupied Budapest in January of 1945, Wallenberg was arrested on suspicion of espionage and transferred to the feared Lubyanka prison in Moscow where he reportedly died [but it has never been confirmed to date].

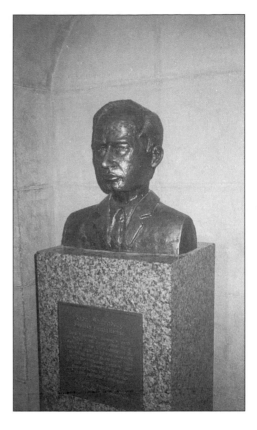

Site 70: The Clerk of the House, H-154. At the beginning of each new Congress [every two years], the House is temporarily led by the Clerk until the new Speaker is chosen. This very important office also receives and verifies the official credentials of each Member, certifies the passage of all final bills, processes all legislation, and authorizes all documents relating to that legislation. When the House of Representatives is not in session, the Clerk receives all official communications from the president and the Senate. A number of additional budgeting, accounting, and housekeeping responsibilities make this a very indispensable appointed officer of the House.

71

Site 71: The Majority Whip [across from Clerk's Office]. Each party appoints one of their Members to help keep other Members of their party informed about the legislative program and debating tactics of upcoming legislation. They are called "whips" because it is their particular job to continue pressing party Members to vote according to the party's goals. The Majority Whip coordinates the assistant whips and briefs the Speaker of the House as legislation and debate progresses, especially during key votes.

Site 72: House Sergeant-at-Arms, H-124. This is an old and ancient office intended to keep the order during legislative sessions. Traditionally, the Sergeant-at-Arms enforces the rules and maintains proper decorum during debates on the House floor. This is usually done through the use of the Mace [Site 82]. When a Member is considered to be unruly, the Sergeant-at-Arms takes the Mace and places it in front of the Member as a symbolic gesture that usually restores order. The Sergeant-at-Arms, along with the Senate counterpart, are also responsible for security in the Capitol and the office buildings.

Site 73: Hall of Capitols. This is truly one of the more interesting corridors in the Capitol, at least to me, because the paintings by Allyn Cox from 1971 through 1974 show all of the meeting places of Congress since before Independence in 1776. I can show only a couple of them here, but the paintings show an evolution beginning in the south corridor [in front of the Sergeant at Arms office and moving toward the north side]. In addition are the portraits of the first nine Architects of the Capitol, the artists and those involved in planning the Capitol, and inspiring inscriptions of past patriots.

"The Meeting Places of Congress" by Allyn Cox, 1974. Shown is Blodgett's Hotel in 1814, the Old Brick Capitol of 1815 [both used after the burning of Washington of August 1814 by British troops], the U.S. Capitol of 1829 with Bulfinch's wooden dome, and the U.S. Capitol of 1867 after the iron dome.

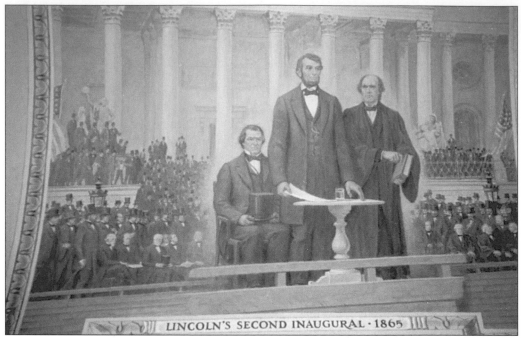

Lincoln's Second Inaugural 1865.

Site 74: Great Experiment Hall. Along the central east-west corridor walls are murals depicting great moments in American history and democratic government. They were painted by Allyn Cox and formally presented to Congress by the Daughters of the American Revolution in 1976 to commemorate the Bicentennial of the United States. Cox died in 1982 shortly after completing the Hall.

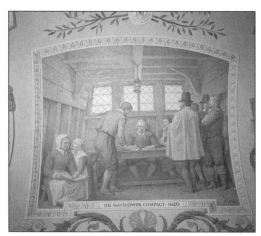

Mayflower Compact, 1620.

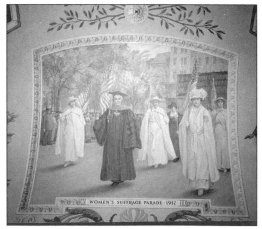

Women's Suffrage Parade, 1917.

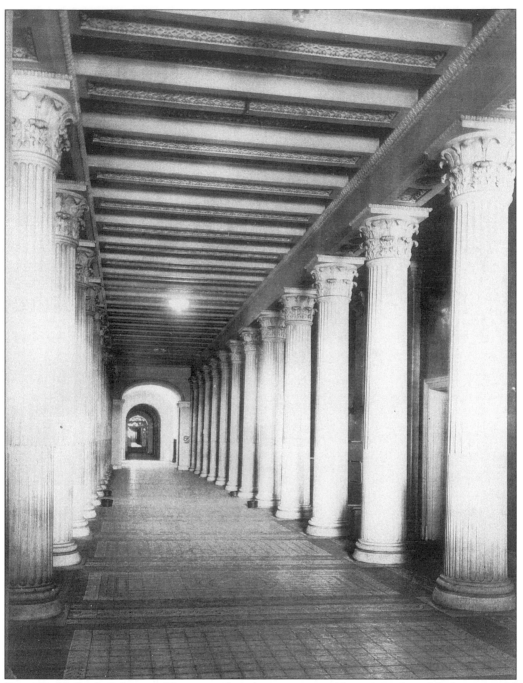

Site 75: Hall of Columns. Here are alternating statues of bronze and marble between 28 columns of white marble which have been an extension of Statuary Hall since 1976. It was created as part of Thomas U. Walter's extension of the U.S. Capitol in the mid-19th century. This corridor was also sometimes called "Tobacco Hall" because of its brown walls and tobacco-leaf carvings along the top of the columns. But there are thistles and acanthus leaves carved in the columns as well. This photo was taken about 1900. Stop a moment and visit with the great historic pioneers of the United States.

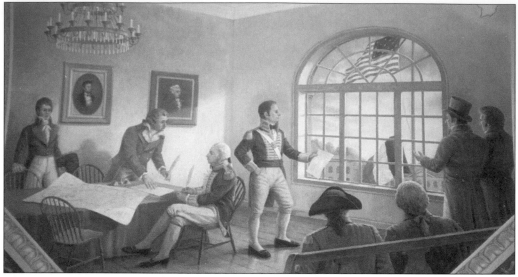

The Louisiana Purchase from Spain, 1803.

Site 76: Westward Expansion Hall. Before February 1993, this was a blank canvas, nothing but pure white walls. After Allyn Cox's death in 1982, Cliff Young, Cox's assistant, began preparations to complete this, the third House corridor, but he died in 1986 before he began to execute his designs. In 1993, EverGreene Painting Studios, Inc., headed by Jeffrey Greene, began transferring Young's and Cox's designs to the walls here using in situ in oil on canvas. This process requires placing canvas on the plaster walls then covering it with a coat of white paint. A cartoon or tracing is sprayed onto the surface using a template and charcoal dust that provided an outline where oil paints could be applied. I can only show a couple of the results here, but the entire Hall was dedicated on Constitution Day September 17, 1993.

The Purchase of Alaska from Russia, 1867.

Senate

Third Floor

House

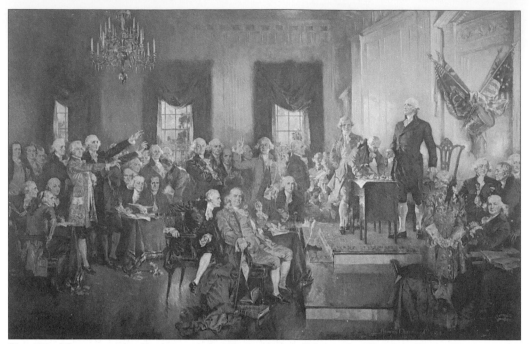

Site 77: "Scene at the Signing of the Constitution." Like the "Battle of Lake Erie" on the Senate side, this is one of several oversized paintings within the Capitol depicting historical events of the United States. On September 17, 1787, delegates to the Constitutional Convention in Independence Hall in Philadelphia are in the process of signing the new Constitution. George Washington presides while Alexander Hamilton talks to Benjamin Franklin [with cane], and James Madison, the chief architect of the document, listens at the table to Franklin's right. Artist Howard Chandler Christy painted this 20-by-30-foot canvas about 1940.

Site 78: "Charles Carroll of Carrollton." Born in Annapolis, Maryland, in 1737, he was an early leader of American independence. As a member of the Continental Congress in 1776, he signed his name to the Declaration of Independence as "Charles Carroll of Carrollton" indicating his home in Maryland—the only delegate to add his address to the document. Later, Carroll was a U.S. Senator from Maryland from 1789 until 1792. He died in 1832 at the advanced age of 95. His brother, John Carroll, was the first Catholic bishop in the United States in 1789 and founded what is now Georgetown University that same year. This painting by Chester Harding was purchased by the U.S. Capitol in 1870.

Site 79: "Henry Clay." Artist John Neagle captures the essence of the powerful personality of Henry Clay in 1843. His Compromise of 1850 kept slavery from being abolished and that act alone is said to have been the precursor to the Civil War ten years later. Andrew Jackson was to have said that he had but two regrets in his life; he could not shoot Henry Clay nor hang John Calhoun. Born in 1777 in Hanover County, Virginia, Clay was a lawyer first, then throughout his life, a congressman, senator, secretary of state, a defeated Whig candidate for president in 1832 and 1844, and generally known as the "Great Pacificator." He died in 1852 at the age of 75.

Site 80: "Gunning Bedford Jr." This is one of the original signers of the Constitution of the United States from Delaware. Prior to that, Bedford was a member of the Continental Congress from 1783 to 1785. Later, Bedford became a state senator in Delaware and a U.S. Judge from 1789 until his death in 1812. His cousin, Gunning Bedford, also of Delaware, became governor in 1796 until his death the next year. Both cousins were involved in the early constitutional history of the United States. This painting of Bedford Jr. is attributed to Charles Willson Peale and was purchased for the U.S. Capitol at the bequest of Henrietta Bedford in 1872.

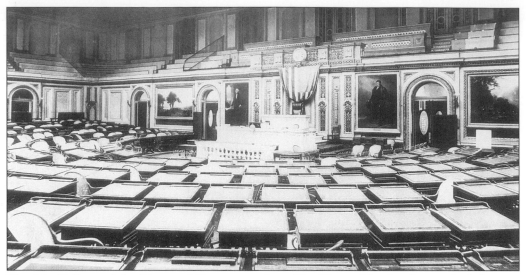

Site 81: Gallery of the House of Representatives. The House, like the Senate, had three or four different sites before settling in this chamber in 1857—two years before the Senate occupied its chamber. The immediate predecessor to this Chamber is now designated as National Statuary Hall, located on the second floor. Members of the House are elected by district within their state with each state, regardless of population, electing at least one representative [in 1911 the number of representatives was capped at 435 in 1911] and serving for two years [with no limits to how many terms a representative can serve unless there is a state term limits law]. The number of representatives from each state is still decided by a census of its population every ten years. In the House, there is no assigned seating. The photo shows the House with a desk for each member, which changed to the current bench system about 1909.

Site 82: Speaker's Rostrum. Just in front of the flag sits the Speaker of the House of Representatives, a constitutional officer. The Speaker need not be a member of Congress [but they all have been] and is elected by the majority party. The speaker is second in line to the presidency after the vice president and can vote on legislation. In 1962 the national motto, "In God We Trust," was added in gold above the Rostrum. Again, the fasces dominates on either side of the Speaker. To our left of the Speaker sits the Parliamentarian and two Sergeants-at-Arms. The Timekeeper is to our right of the Speaker. The Journal Clerk, Tally Clerk, and Reading Clerks sit below the Speaker with the official House reporters below them.

Site 83: The Mace. What began as a weapon of war, now serves as the symbol of peace and authority. This mace was created of ebony and silver in 1841 by William Adams and is a reproduction of the original mace destroyed by the British in August of 1814. The 13 ebony rods represent the original colonies. The mace is placed on the green marble pedestal to the right of the Speaker during regular session of the House, and lowered to the smaller base when the House is in Committee of the Whole (the entire House becomes a committee).

Site 84: George Washington. To our left of the Speaker's Rostrum is the painting of the first president of the United States under the Constitution from 1789 to 1797. As commander-in-chief of the Continental Forces during the Revolutionary War [1775–1781], Washington helped lead the armies of the individual colonies—then states—to victory at Yorktown, Virginia, in 1781. He was born in Westmoreland County, Virginia, in 1732 and trained as a surveyor. His military career began in the Virginia militia during the French and Indian Wars of the 1750s. Later, he served in the House of Burgesses, Continental Congress, and presided at the Constitutional Convention of 1787. Washington retired to his home at Mount Vernon, Virginia, in 1797. He died in 1799 at the age of 67. The portrait was commissioned by Congress in 1832 and is by John Vanderlyn.

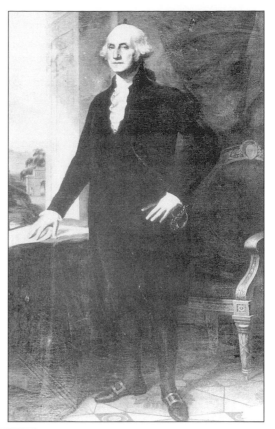

Site 85: Marquis de Lafayette. To our right of the Speaker's Rostrum is a large painting of Marie Joseph Paul Yves Roch Gilbert du Motier de Lafayette, a French officer commissioned a major general in the Continental Army in 1777 who became aide-de-camp to General George Washington. He was instrumental in the defeat of British forces in Yorktown, Virginia, in 1781, which secured the freedom of the United States. He returned to France and faced a different uprising—the French Revolution of 1789. Lafayette returned to the United States for a triumphant visit in 1824. He died in 1834 when he was 77. The painting was a gift to the House of Representatives by the artist, Ary Scheffer, in 1824.

Site 86: Democratic Party Representatives. Since there is no assigned seating, by tradition the Democrats sit to our left. The Democratic Party of the United States is the oldest continuous political party in the world originally founded as opposition to the Federalists of the 1780s. Thomas Jefferson was the first president under the Democratic-Republican party, as it was originally known, and as it grew it changed into a more progressively 'anti-establishment' party under President Andrew Jackson with his election in 1828. The presidencies of Woodrow Wilson [1913–1921] and Franklin Delano Roosevelt [1933–1945] help define the Democratic Party as a party of "the common man." The domestic donkey was popularized as the party symbol by Thomas Nast, a cartoonist and satirist of the late 19th century, and represents the stubbornness in protecting the rights of the working class.

Site 87: Republican Party Representatives. The Republicans sit to our right. This is the youngest of the two major parties of the United States, established in 1854 after the collapse of the Federalist and Whig parties before it. President Abraham Lincoln [1861–1865] was the Republican's first president and until the Great Depression, every president was Republican except for Grover Cleveland and Woodrow Wilson. Traditionally, the party is supported by those with higher-than-average incomes, higher education, and big business. Their philosophy is to limit government in social programs and the protection of states' rights. President Ronald Reagan [1981–1989] is uniquely associated with the Republican Party objectives. The large elephant, the party's symbol, is also a creation of Thomas Nast and represents the ponderous weight of sudden changes.

REPORTERS GALLERY
U.S. SENATE
Impeachment of the President
ADMIT THE BEARER
March 13-1868.

No. 15

Geo. T. Brown
Sergeant-at-Arms.

Philp & Solomons, Wash. D.C.

Site 88: Press Gallery. In the gallery, just above and behind the Speaker sits the individuals especially accredited to cover debates in the House of Representatives. At this writing, there are nearly 2,500 representatives of newspaper, radio, and television accredited to the House and the Senate from around the world. Television coverage began in the House in 1979 and the Senate in 1986. All cameras are operated under the Cable-Satellite Public Affairs Network (C-SPAN), a nonprofit, cable-industry-supported television network.

Site 89: Voting in the House. Located just below where you are seated and in the gallery opposite you, behind the speaker, are 44 electronic voting machines which were installed in 1973. Each member is issued a special card similar in size to a standard credit card. When a vote is called for on the floor, bells go off around the Capitol and in the House Office buildings to call members to the floor to vote. Members have 15 minutes to walk to the House Chamber [the only place they can vote], insert their card [as I've demonstrated here since no photo was allowed], and answer the vote with yea, nea, abstain, or present. The total is added up on the large dark screens behind the Speaker's Rostrum.

★ ★ ★ LET US DEVELOPE THE RESOURCES OF OUR LAND, CALL FORTH ITS POWERS, BUILD UP ITS INSTITUTIONS, PROMOTE ALL ITS GREAT INTERESTS AND SEE WHETHER WE ALSO IN OUR DAY AND GENERATION MAY NOT PERFORM SOMETHING WORTHY TO BE REMEMBERED
DANIEL WEBSTER

Site 90: Webster Quotation (behind Speaker Rostrum). ". . . Let us develop the resources of our land, call forth its powers, build up its institutions, promote all its great interests and see whether we also in our day and generation may not perform something worthy to be remembered." These words are taken from a speech by former Senator Daniel Webster of New Hampshire at the laying of the cornerstone of the Bunker Hill Monument near Boston, Massachusetts, June 17, 1825. The quote, in marble, was placed above the gallery door in 1950.

The next few pages highlight 23 influential lawgivers throughout world history created in bas relief of white Vermont marble and placed in the House during remodeling in 1949–50. Each were chosen by a special committee of the House in consultation with the University of Pittsburgh, the Historical Society of Washington, D.C., and the Library of Congress.

Site 91: George Mason. This influential planter was born in 1725 and raised in Fairfax County, Virginia. He was elected to the Virginia House of Burgesses in 1759 where he wrote the famous Fairfax Resolves which made it illegal to import goods, especially tea, from Great Britain. Later, Mason would write the Declaration of Rights and the Virginia Constitution in 1776. As a member of the Constitutional Convention in 1787, he argued forcefully for a guarantee of rights, which were later adopted as the Bill of Rights, the first ten amendments to the Constitution. Mason died in 1792 at the age of 67.

84

Site 92: Robert Joseph Pothier. This French jurist was the author of *Pandectae Justinianae in novum ordinem digestae*, a study of Roman law. He is best known for his legal treatises that were incorporated as the basis of the French Code Civil. Pothier died in 1772 at the age of 73. This bas relief carving is by Joseph Kiselewski.

Site 93: Jean Baptiste Colbert. Colbert was another French influence in codifying the ordinances that became the basis of French law. Colbert, as controller general of finance in 1665, reformed the administration and collection of taxes. As the minister of marine he created the French navy in 1669. He revised the civil code including the introduction of the "code noir" or colonial codes for the French territories. Later he founded the Academie des Inscriptions et Belles-Lettres in 1663 and the Academie des Sciences in 1666. He died in 1683 at the age of 64.

Site 94: Edward I. As Plantagenet King of England from 1272 to 1307, Edward I successfully reformed the administration of England by reforming feudalism in 1275, the practice where a vassal worked the land of the local lord without benefit of ownership. Edward I created the first "Model Parliament" in 1295, which generated the parliamentary system of government, the first time a representative system took hold in England since Magna Carta was signed in 1215. He also provided Scotland with a new Constitution and gave it representation in the English Parliament. Edward I died in 1307 and is buried in Westminster Abbey. The bas relief is by sculptor Laura Gardin Fraser.

Site 95: Alphonso X. As King of Leon and Castile of Spain, he authored the *Fuero Real,* which brought together local legislation as a compendium for the use of local magistrates. His *Las Sietes Pardidas* was used for the basis of jurisprudence in Spain. Alphonso X died in 1284 at the age 63.

Site 96: Gregory IX. Born Ugolino or Ugo, Count of Segni in 1147, he was elected Pope in 1227. He immediately almost excommunicated Emperor Frederick II because he refused to lead an army during the Crusades and for his invasion of Sardinia, an Italian province in 1239. Gregory IX helped establish the Holy Office of the Inquisition about 1232, but is best known for his Decretals in 1234 that created a code of canon law. He died in 1241 at the very advanced age of 94. The bas relief is created by Thomas Hudson Jones.

Site 97: Louis IX. Universally known as Saint Louis, he ascended to the throne of France when he was 13 years old in 1226. He led the Seventh Crusade from 1248 to 1254, but was captured in Egypt in 1250 where he spent the next four years. In 1258 he signed the Treaty of Corbeil, which gave up Roussillon and Barcelona, but in the Treaty of Paris in 1259 he took possession of Normandy, Anjou, Touraine, Maine, and Poitou and recognized Henry III as Duke of Aquitaine thereby gaining peace with England. St. Louis is best known for his work *Mise of Amiens*, a judgment on a dispute between Henry III and his rebellious English barons, which helped bring peace within England. He went on another crusade to Tunisia in 1270 and captured Carthage, but died of the plague that year. He was 56. For his persistence in the Crusades, he was made a saint in 1297 by Pope Boniface VIII.

Site 98: Justinian I. Named Flavius Petrus Sabbatius Justinianus the Great when Emperor of the Eastern Roman Empire from 527 to 565, his early military exploits included wars against the Goths for Italy and North Africa. He is best known for building public buildings, monasteries, especially the Hagia Sophia in Constantinople in 532. Justinian preserved the Roman law by collecting in a digest all of the writings of Roman jurists to be issued as *Corpus Juris Civilis*, described as the foundation of most of today's European laws. Justinian died in 565 at the age of 82. Gaetano Cecere sculpted his bas relief.

Site 99: Tribonian. He is the chief legal minister who was appointed one of ten commissioners under Justinian I. He lived from about 500 to 547. The bas relief was sculpted by Brenda Putnam in 1950.

Site 100: Lycurgus. Born in Sparta, a city-state of ancient Greece, known for its military strength and civic austerity [the word *spartan* means living simply] in the 9th century, Lycurgus was responsible for instituting by decree its laws and legal institutions. The bas relief is sculpted by C. Paul Jennewein.

Site 101: Hammurabi. This early Babylonian King (1792–1750 B.C.) conquered southern Babylonia and Larsa in 1762 B.C. [now part of Iraq and Iran] but is best known for creating the earliest surviving legal codes in 1780 B.C., which you can see carved in basalt 8 feet high in the Louvre Museum in Paris, France. He died in 1750 B.C. at the age of 42. The bas relief is by Thomas Hudson Jones.

Site 102: Moses. The Hebrew prophet, according to the Biblical book of Exodus, led the enslaved Israelites from Egypt through the Sinai desert for 40 years looking for the valley of Canaan promised to the descendants of Abraham. His discipline established the religious community of Israel and created its judicial laws from the Ten Commandments. Moses is traditionally said to have lived from the 14th to the 13th century B.C. and been born in Egypt. He is credited with writing the Pentateuch, the first five books of the Bible known as Genesis, Exodus, Leviticus, Numbers, and Deuteronomy. The bas relief sculptor is by Jean de Marco.

Site 103: Solon. Born in 630 B.C., he is considered to be one of the Seven Wise Men of Greece and the first great poet of Athens. In 594 B.C. he was elected archon and initiated economic and constitutional reforms that, among other things, reformed the Senate and assembly, minted new coinage along a universal standard, created a uniform weights and measures, and strengthened trade. Opposition to his reforms drove him from Greece for ten years. He died in 560 B.C. at the age of 70. His bas relief is the work of Brenda Putnam.

Site 104: Papinian. Aemilius Papinianus was born 140 A.D. and became one of the greatest jurists of Rome. In *Art in the United States Capitol* it is written that Papinian was ". . . remarkable for his juridical genius, independence of judgment, lucidity and firmness, and for his sense of right and morality by which he frequently rose above the barriers of national prejudices." He was appointed praetorian prefect in 203 A.D. by Emperor Septimius Severus, but executed by Emperor Caracalla when he came to power in 212 A.D.

Site 105: Gaius. As a Roman jurist, his chief work *Institutiones* in c. 161 A.D. became the basis for the famous Institutes of Justinian, the basis of Roman civil law. He died in 180 A.D. at the age of 50. His likeness is the work of Joseph Kiselewski.

Site 106: Maimonides. Born Moses ben Maimon in 1135 in Spain, Maimonides was the foremost Jewish philosopher who immigrated to Egypt in 1166 and became physician to Saladin. He wrote rabbinical letters on logic, mathematics, medicine, law, and theology mostly in Arabic. He attempted to reconcile rabbinic Judaism with Aristotelianism ". . . as modified by Arabic interpretation [Merriam Webster's Biographical Dictionary]." He compiled a systematic exposition of Jewish law in the Pentateuch, the first five books of the Bible. Maimonides died in 1204 at the age of 69. The bas relief is by Brenda Putnam.

Site 107: Suleiman. Called The Magnificent, this Sultan of Turkey from 1520 to 1566 reformed the administration of Turkey to include the civil and military codes, the finest period of the Ottoman Empire. Turkey, thanks to Suleiman's build up of his naval power, was the dominant power in the Mediterranean and was able to defeat Hungary, Iraq, Transylvania, and Tripoli. He died at the age of 70 or 71. The sculptor Joseph Kiselewski captures the Turkish leader in this bas relief.

Site 108: Innocent III. Lothar of Signi ascended to the papacy in 1198 and almost immediately continued Pope Gregory VII's policy of establishing the papacy as a power in Europe. In 1202 his Fourth Crusade resulted in the capture of Constantinople. Later he deposed King John of England in 1212, supported the election of Otto IV as king of Germany in 1207 then deposed him in 1215 in favor of Frederick II of Sicily as emperor. *Art in the United States Capitol* describes Innocent as a "[s]tudent of canon and civil law, who . . . preserved the remnants of Roman law during a dark and critical period of human history." Pope Innocent III died in 1216 at the age of 55. The bas relief is by Joseph Kiselewski.

Site 109: Simon de Montfort. The Earl of Leicester was born in Normandy *c.* 1208 and married the sister of King Henry III in 1238. In the Mad Parliament, for example, he signed the Provisions of Oxford in 1258, which Henry declared invalid. Simon withdrew to France, raged war with Henry, and captured him in 1264 allowing Simon to act as "governor" of England in January 1265. He summoned a Parliament that included churchmen, barons, knights, and, for the first time, two citizens from each borough. This is credited as the beginning of the present-day Parliament. Simon was defeated and killed in August of 1265 because of his alliance with Wales. He is known as Simon the Righteous. His likeness was created by Gaetano Cecere.

Site 110: Hugo Grotius. Also known as Hugo de Groot, Grotius was born in Holland in 1583. He began publishing articles on Latin and law when he was 15 and became the Latin historiographer to Holland when he was 18, attorney general for the province of Holland at 24, and continued publishing Latin and law texts even in prison from 1618 to 1621. He escaped and fled to Paris. In 1625 he wrote on the jurisprudence of Holland and in 1637 a fundamental work on international law. He died in 1645 at the age of 62. The bas relief of Grotius was created by C. Paul Jennewein.

Site 111: Sir William Blackstone. His name is synonymous with influencing the fundamental concept of legal procedure in the early United States. His *Commentaries on the Laws of England* written from 1765 to 1769 are a classic standard to this day. Blackstone was born in England in 1723 and a Fellow at Oxford at 21 and professor of common law from 1758 to 1766. He was a member of Parliament and the Queen's Solicitor General in 1763 and died as a judge of the Common Pleas Court in 1780. Blackstone is sculpted by Thomas Hudson Jones.

Site 112: Napolean I. Napolean Bonaparte was born in 1769, the son of a lawyer. He entered the French military in 1785 and after several civil and international military campaigns [in Egypt, Italy, Austria, Malta, Syria] he returned to Paris to overthrow the government in 1799 and became Consul for Life in 1802. During his tenure he sold Louisiana to the United States in 1803 and created the Code Napoleon, a codification of laws of France in 1804, a significant contribution to the legal systems of Europe and North America. After that, well, he continued conquering Europe and eventually lost out to the Allies in 1815. He died in 1821 at the age of 52. The bas relief sculpture is by C. Paul Jennewein.

Site 113: Thomas Jefferson. He was a member of the House of Burgesses at 26 from Albemarle County, Virginia, and circulated *Summary View of the Rights of British America*, among other widely read pamphlets attacking England's role in North America. As a member of the Continental Congress, Jefferson drafted the document that would become the Declaration of Independence, signed in July 1776. Later, he became governor of Virginia, Minister to France, secretary of state, leader of the Democratic-Republican party, vice president of the United States, and third president of the United States from 1801 to 1809. After the presidency, Jefferson founded the University of Virginia, was a noted naturalist, scholar, and architect. His likeness was created by C. Paul Jennewin.

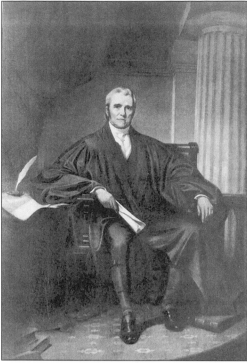

Site 114: John Marshall. Born in 1755 in what is now Midland, Virginia, John served with his father, Thomas Marshall, in the Battle of Brandywine during the American Revolution. After the war, John became a lawyer and served in the House of Burgesses and the House of Representatives, then became U.S. Secretary of State and was appointed Chief Justice of the United States Supreme Court in 1801. Marshall led the Supreme Court in creating the doctrine of judicial review, the principal foundation of the American legal system in *Marbury v. Madison* in 1803, and other landmark decisions. Marshall remained at the Supreme Court until his death in 1835. The painting is by Richard N. Brooke in 1880 and was purchased for the Capitol in 1881.

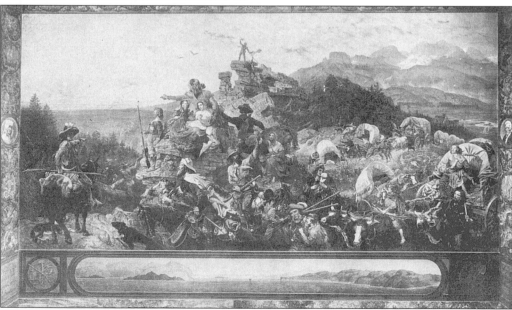

Site 115: "Westward the Course of Empire Takes Its Way." Gold, or even better, land helped attract new settlers to the relatively unpopulated Western lands of the United States beginning in the early 19th century. Painter Emanuel Leutze captures the scene of settlers at the continental divide looking towards the Pacific Ocean as he painted them in 1862. From 1840 to 1860 the population of the United States nearly doubled to 31 million, and the availability of new western lands after 1860 helped spread the growth and fulfill the "Manifest Destiny" of creating a country ". . . from sea to shining sea."

Site 116: Committee Rooms of the House and Senate. "Congress in its committee rooms is Congress at work." This quote from President Woodrow Wilson really captures the essence of work in Congress today. There are basically four types of committees: standing committees (they are permanent), select or special committees (they exist for a special purpose or for a specific time), joint committees (they have membership from both the House and Senate and may or may not be standing committees as well), and conference committees (they are usually related to ironing out the differences in the same piece of legislation between members of both the House and Senate only). When you visit the House or Senate and you do not see your members on the floor, they are usually in committees located in office buildings or within the Capitol itself.

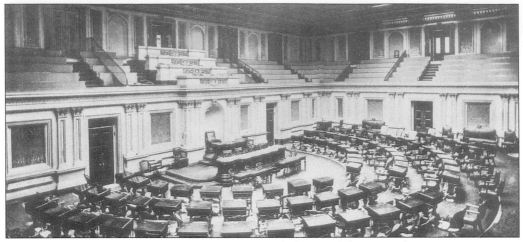

Site 117: U.S. Senate Gallery. This is the fourth home of the United States Senate since Congress moved to Washington, D.C., in 1800. For ten years, the Old Senate Chamber was the first site, then the Old Supreme Court Chamber served from 1810 through 1819 (from 1814 to 1817 the Senate occupied the Old Brick Capitol—where the Supreme Court is today—while the Capitol was being repaired after the British invasion of 1814). From 1819 until 1859, the Senate met in what is now Statuary Hall. In 1859 the Senate moved here. The Constitution allows for two senators from each state who are no less than 30 years old and have lived in the U.S. for no less than nine years. The 17th Amendment allows senators to be elected by ballot instead of by appointment by the state legislature. Each term is six years with no limit placed on the number of terms a senator can serve, unless there is a state term limits law in effect. This photo was taken about 1900 and doesn't show the U.S. flag behind the rostrum.

Site 118: The Senate Rostrum. In front of the U.S. flag sits the vice president of the United States acting constitutionally as president of the Senate (and addressed as Mr. or Madam President), but he votes only when there is a tie. In the absence of the vice president, a president pro tempore presides, usually the most senior senator of the majority party. The secretary of the senate is to the left; the sergeant at arms is to the right; the chief clerk, legislative clerk, parliamentarian, and journal clerk sit below the senate president; and the official reporters sit in front.

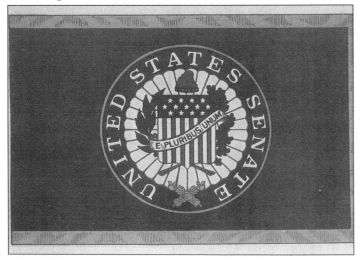

Site 119: Flag of the Senate. The Flag of the United States on the left of the presiding officer's chair shows 13 stripes of alternating white and red that represent the original 13 colonies and a dark blue canton of 50 stars (one for each state). To the right of the presiding officer's chair is the Flag of the Senate, showing the Senate seal on a dark blue background. [See Site 45 for a more complete description and history.]

Site 120: The Senate Majority Leader. Before 1920, there was no specific designation for the leader of the Senate. The committee chairman or an individual senator exerted great influence over individual pieces of legislation. In 1920, the Democrats (and in 1925, the Republicans) finally designated one of their own to manage all legislation on the floor of the House. The practice evolved so that the majority party began setting the schedules for the entire Senate membership. Today, the majority leader is the central focus of day-to-day activities in the Senate. Both the majority and minority leaders occupy the two desks just below the Rostrum. This photo is of former president Lyndon B. Johnson (1963–1969), who was one of the most formidable majority leaders on record.

Site 121: The Senate Membership. Each senator has their own assigned desk arranged with the Democrats on the left and the Republicans on the right. Each state, regardless of its size, is entitled to two senators. A senator must be at least 30 years old and a citizen of the United States for no less than nine years. After the burning of the Capitol in 1814, all of the furnishings and desks were destroyed. Thomas Constantine, a New York cabinetmaker, created 48 new desks for the Senate in 1819 when the Old Senate Chamber was rebuilt (he created new desks for the House, too). All of Constantine's desks are still in use today. Since the early 1900s, senators have carved, or have had carved, their names into their personal desks, a Senate tradition that lingers to this day. Since a photo of the desks was not possible, here is a print of a drawing of a new Senate chair designed by Architect Thomas U. Walter in 1857. It is unknown whether these chairs were ever built.

The next few pages feature statues placed around the perimeter of the U.S. Senate chamber and represent the vice presidents who have served as president of the Senate throughout its history.

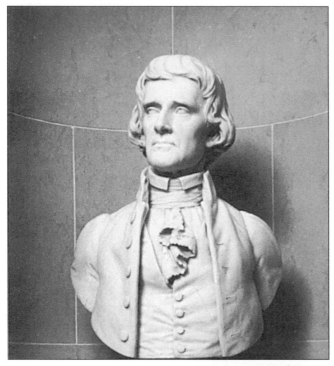

Site 122: Thomas Jefferson. As you know, Jefferson was the third president of the United States, but he is represented here because he was also the second vice president of the United States under President John Adams (who was, himself, vice president under George Washington) from 1797 to 1801. In the early years of the United States, votes for president and vice president were separate. The top vote getter became president, the second became vice president. That is why Adams, a Federalist, was stuck with Jefferson, a Democrat, as his vice president. This 1889 statue is by Sir Moses Ezekiel.

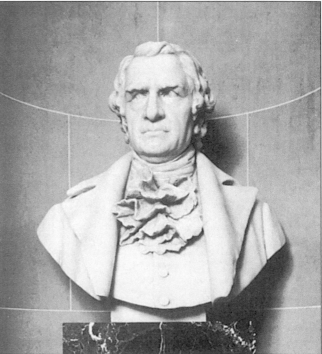

Site 123: George Clinton. Ironically, Clinton was born in Little Britain, New York, in 1739 and went on to fight the British as brigadier general of militia in 1775 and in the Continental Army in 1777. Later that same year, Clinton became governor of New York for the first of two times (1777–1795; 1801–1805), after which he became Jefferson's vice president during his second term and then vice president under James Monroe. Clinton died in office in 1812. His statue was sculpted by Vittorio A. Ciani in 1894.

Site 124: Daniel D. Tompkins. Like George Clinton, Tompkins became vice president under the fifth president, James Monroe, after serving as governor of New York from 1807 to 1817. Prior to that he served as an associate justice of the New York State Supreme Court from 1804 to 1807. He was born in 1774 and died in 1825 at the age of 48. His likeness was sculpted by Charles H. Niehaus in 1891.

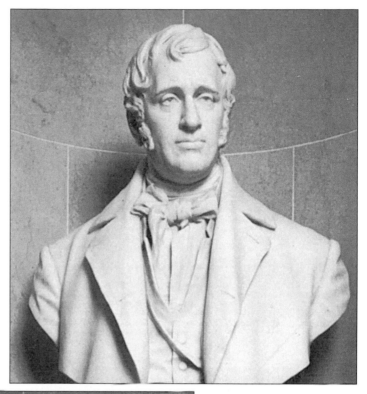

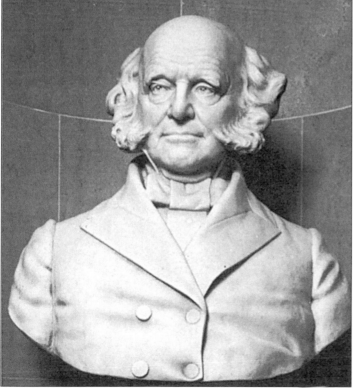

Site 125: Martin Van Buren. In 1837, Van Buren became the first native-born American to become president of the United States. Van Buren was a lawyer and the attorney general of New York; he then became a U.S. senator (1821–1828) and, later, governor of New York in 1829. He resigned to become the secretary of state to President Andrew Jackson. During Jackson's second term, Van Buren became his vice president (1832–1837). That year, Van Buren became the eighth president of the United States. The bust of Van Buren was created by U.S.J. Dunbar in 1894.

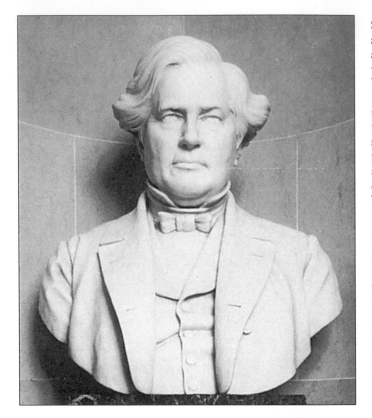

Site 126: John Tyler. Talk about being in the right place at the right time. Tyler was vice president to President William Henry Harrison in 1841 until Harrison died one month into his term. Under the Constitution, Tyler succeeded him, becoming the first vice president to succeed a president who had died in office. Prior to his elevation, Tyler was a member of the House of Representatives, the governor of Virginia, a U.S. Senator, and the vice president of the United States. During his term, Texas was annexed to the Union. He died in 1862 as a member of the Confederate Congress from Virginia. His statue is by William C. McCauslen and was sculpted in 1898.

Site 127: Millard Fillmore. Zachary Taylor became the 12th president of the United States in 1849 but died in 1850. Fillmore, his vice president, became the second vice president to succeed to the presidency after the death of the incumbent. Fillmore had previously served as a member of the House of Representatives before becoming vice president. During his term he signed the Fugitive Slave Law requiring escaped slaves to be returned to their "masters" or face imprisonment, and he sent Matthew Perry to Japan in 1853. He lost his bid for reelection in both 1852 and 1856. Fillmore died in 1874 at the age of 74. His statue was created by Robert Cushing in 1895.

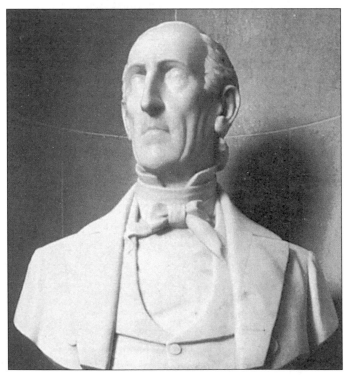

Site 128: John Breckenridge. Born near Lexington, Kentucky, in 1821, Breckenridge became a member of the House of Representatives when he was 30 years old and served as vice president under James Buchanan, the 15th president, from 1857 to 1861. His bid for reelection as a Southern candidate failed, and he briefly became a U.S. senator after leaving office. He resigned in 1861 to join the Confederate army, became a major general in 1862 and the secretary of war of the Confederate States in 1865. He died in 1875 at the age of 56. James Paxton Voorhees created this statue in 1896.

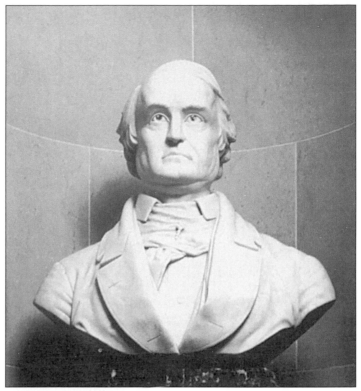

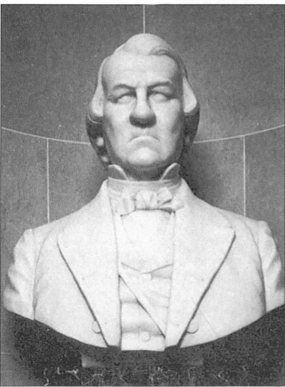

Site 129: Andrew Johnson. Apprenticed to a tailor when he was young, Johnson could neither read nor write until his wife taught him. Still, he became a member of the House of Representatives in 1843, then the governor of Tennessee and a U.S. Senator. He remained loyal to the Union, even though he was from a "southern state" and became the military governor of Tennessee from 1862 to 1864. When President Abraham Lincoln was reelected in 1865, Johnson, a compromise candidate, became his vice president—until Lincoln's assassination on April 14, 1865, at Ford's Theater. Johnson was thrust into the presidency and his differences with Congress led to his impeachment in the House, though he was acquitted by the Senate—by one vote. After the presidency he became a U.S. Senator and served in that capacity until his death in 1875. His statue was sculpted by William C. McCauslen in 1900.

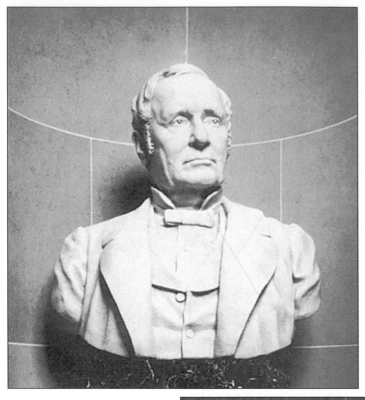

Site 130: William A. Wheeler. As were many vice presidents, Wheeler was from New York, where he served his state in the U.S. House of Representatives from 1861 to 1863 and then again from 1869 until 1877, when he became vice president to the 19th president of the United States, Rutherford B. Hayes. Wheeler served until 1881 and died in 1887 at the age of 68. This 1892 statue is by Edward C. Potter.

Site 131: Thomas Hendricks. He was born near Zanesville, Ohio, in 1819, but moved to Indiana to become a member of the House of Representatives (1851–1855), then a U.S. senator (1863–1869), and the governor of Indiana in 1872. He was originally a vice presidential candidate with Samuel Tilden in 1876. They received the most popular votes but fewer electoral college votes, so they lost. However, Hendricks became vice president under Grover Cleveland in 1885 but died later that same year at the age of 65. Sculptor U.S.J. Dunbar created this likeness in 1890.

Site 132: Chester A. Arthur. Born in Fairfield, Vermont, in 1829 to a Baptist minister, Arthur began practicing law in 1853 in New York City. He became a trusted member of the Republican Party and was appointed as quartermaster general of New York and collector of the port of New York. He was nominated as vice president under James A. Garfield to appease other Republicans, and he won the 1880 election. Garfield was assassinated in Washington, D.C., in September and Arthur gained the presidency and served out Garfield's term. Arthur died in 1886 in New York City at the age of 57. His likeness was created by Augustus Saint-Gaudens in 1892.

Site 133: Schuyler Colfax. Born in New York City in 1823, Colfax and his family must have migrated to Indiana because in 1855 he became a Republican member of the House of Representatives from that state. Colfax became Speaker of the House (1863–1869) and was nominated for the vice presidency under Ulysses S. Grant for the 1868 election and won. He was not renominated for Grant's second term in 1872 because of his part in the infamous Credit Mobilier scandal that ended his political career. He died in 1885 at the age of 62. This statue was created by Frances M. Goodwin in 1897.

Site 134: Hannibal Hamlin. He was a prominent Republican member of the House of Representatives from 1843 to 1847, when he was appointed U.S. senator (senators were appointed by each state's legislative body until 1913) in 1848 and served until 1861 (with a short one-year stint as governor of Maine in 1857). He became vice president under Abraham Lincoln during his first term. Andrew Johnson was nominated for Lincoln's second term and Hamlin again became a U.S. senator, serving from 1869 until 1881, when he began his final career as ambassador to Spain from 1881 to 1882. He died in 1891 at the age of 82. His statue is by Franklin Simmons and was created in 1890.

Site 135: William R. King. He was born in Sampson County, North Carolina, in 1786 but migrated to Alabama in 1818. The next year King was appointed a U.S. Senator (1819–1853) with four years in between spent as an ambassador to France. In 1853 William Rufus de Vane King became vice president of the United States under Franklin Pierce, the 14th president. King died the same year at the age of 67. His statue in the Senate Chamber gallery was made by William C. McCauslen in 1896.

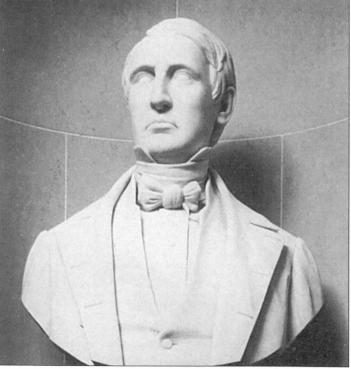

Site 136: George M. Dallas. Yes, the city in Texas is named for him although he was originally born in Philadelphia in 1792. The short bio provided shows Dallas to have been a U.S. Senator from 1831 through 1833, then ambassador to Russia from 1837 to 1839. Later, in 1845, Dallas became vice president under James K. Polk, the 11th president of the United States. You'll have to read about Dallas's exploits in Texas on your own. His statue is by Henry J. Ellicott and was created in 1894.

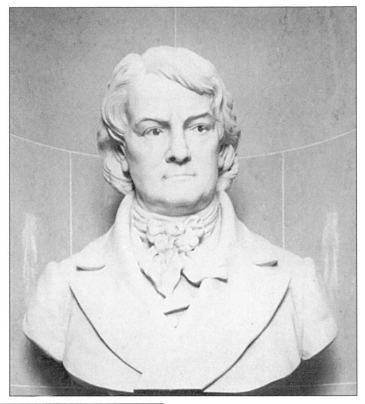

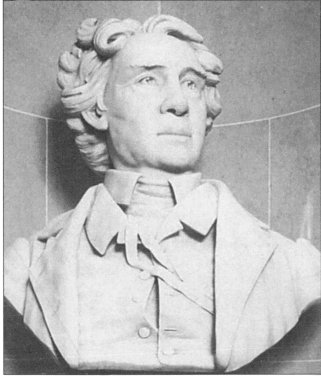

Site 137: Richard M. Johnson. During the War of 1812, Richard Mentor Johnson reputedly killed Tecumseh in 1813 at the Battle of the Thames, while technically serving as a congressman from Kentucky. He served in the House of Representatives from 1807 to 1819, then in the U.S. Senate until 1829, and back to the House until 1837. No candidate received enough electoral college in the election of 1836 to qualify for vice president, so the election was thrown into the U.S. Senate, which promptly elected Johnson. He served with Martin Van Buren, the eighth president of the United States, until 1841. Johnson died in 1850 at the age of 70. The statue honoring him was created by James P. Voorhees in 1895.

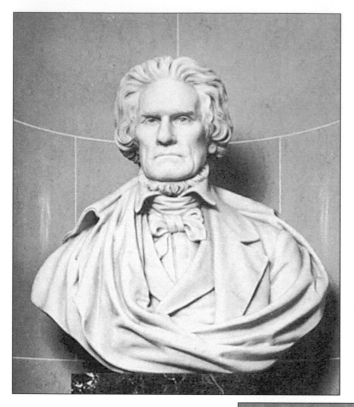

Site 138: John C. Calhoun. Calhoun began his career as a member of the House of Representatives from 1811 to 1817. He was a champion of slavery, and the rights of the Southern states became his lifelong cause, especially in the U.S. Senate for South Carolina, where he served after resigning the vice presidency in 1832 (he served under John Quincy Adams from 1825 to 1829 and under Andrew Jackson from 1829 to 1832). Calhoun served in the Senate until 1843, when he became the secretary of state (1844–1845) under President John Tyler. He then returned to the U.S. Senate (remember, senators were appointed then, not elected). His statue was created by Theodore A. Mills in 1896.

Site 139: Elbridge Gerry. During his long career, Gerry was a member in the Continental Congress, and a Massachusetts signer of the Declaration of Independence and the Articles of Confederation. He was also a delegate to the Constitutional Convention in 1787 but refused to sign the document. He was a member of the House of Representatives, and then governor of Massachusetts from 1810 to 1812. After he redrew the state political boundaries to benefit his Whig Party, one district looked like a salamander, and the procedure has been known as "gerrymandering" ever since. Gerry was vice president from 1813 (under James Madison, the fourth president) until his death in 1814 at the age of 70. The statue in the Senate chamber is by Herbert Adams and was created in 1892.

Site 140: Aaron Burr. This interesting character was born in Newark, New Jersey, in 1756 and served in the Revolutionary War until 1779, when he left to practice law in New York City. He served as a U.S. Senator from 1791 to 1797. He ran for president in 1800 against Thomas Jefferson and ended up in a tie. On the 36th ballot, Jefferson was elected president; Burr was vice president from 1801 to 1805. In 1804—while he was vice president—Burr challenged Alexander Hamilton to a duel and killed him. In 1807, he conspired to set up his own republic from lands seized by the Spanish in the Southwest and failed. He was acquitted of treason. Burr left the country in 1808 to interest France and England on another try, but failed that, too. He finally came home in 1812 and returned to law, which he practiced until his death in 1836. You can see his fighting spirit in this statue created by Jacques Jouvenal in 1894.

Site 141: John Adams. Its ironic that we end this series of vice presidents with John Adams since both he and Thomas Jefferson (the first in our series) died on the same day—July 4, 1826, the 50th anniversary of the Declaration of Independence. Adams was born in Massachusetts in 1735 and served in the Continental Congress, as well as helped to draft the Declaration of Independence with Jefferson. He went on to become commissioner to France, negotiated treaties with France and England, and was elected vice president for both the terms of George Washington from 1789 to 1797. He was elected the second president of the United States in 1797 and was the first president to live in the White House. Daniel Chester French, the noted sculptor of the Lincoln Memorial, created this statue in 1890.

Site 142: *Recall of Columbus*. This painting shows Christopher Columbus on the road to France, seeking help for his last voyage to the Americas after being turned down by Queen Isabella of Spain. Later, Isabella relented and sent a messenger to overtake Columbus. He is shown here conveying the Queen's message on the bridge of Pinos near Granada, Spain. When Augustus G. Heaton painted this in 1882, it is said he used a virtual likeness of Columbus from other paintings and engravings taken of him during his lifetime. The painting has been on permanent exhibit in the U.S. Capitol since it was purchased in 1884.

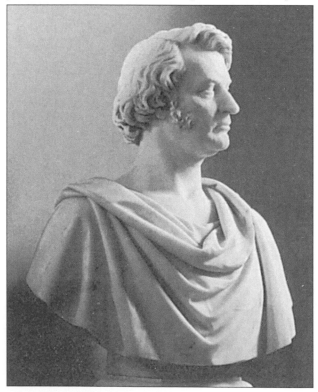

Site 143: Charles Sumner. We heard from ardent pro-slavery Senator John C. Calhoun earlier; now meet an equally anti-slavery senator from Massachusetts: Charles Sumner. In fact, there is a famous story that he verbally taunted the defenders of slavery so savagely that Representative Preston Brooks of South Carolina, a pro-slavery advocate, beat him almost to death on the House floor in 1856. Sumner never fully recovered. He advocated the impeachment of President Andrew Johnson in 1868. Sumner died in 1874 at the age of 63. His statue, a gift of Anna Shaw Curtis in 1894, is by Martin Milmore.

Site 144: Lay Lights. Here are two unique and unusual architectural elements left over from the original Senate extension of 1859. The photograph shows the wonderful painted glass as seen from the second floor. These lights were created by the J & G.H. Gibson Co. from a process known as "triple enameled glass" in which the design is painted onto the surface of leaded glass [also see Site 45, the Senate seal].

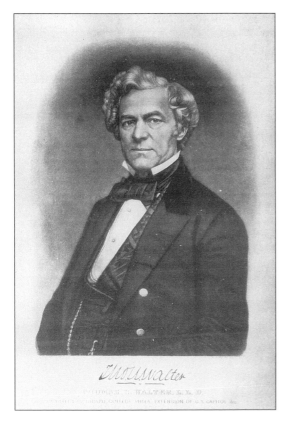

Site 145: Early Skylight. [No early image was available and photos are not allowed on the third floor.] Look up at the ceiling and you will see a skylight that originally sent sunlight through the lay lights above to provide light to the second floor. They were a part of the original Senate extension of 1859 by the fourth architect of the Capitol, Thomas U. Walter (at left), and were utilized throughout the 19th century. The skylight was covered over in 1901, when electric lights were added to the Capitol. As of this writing, legislation is being considered that would restore the skylight to its original purpose of once again using natural light.

Site 146: Beeshekee (Buffalo). With the Chippewa chief, Flatmouth, Chief Beeshekee of the Chippewa visited Washington in 1854 to complete a land treaty and, while here, sat for a marble bust by the sculptor Francis Vincenti. This bronze bust, however, was a likeness taken from Vincenti's bust and was created by Joseph Lassalle, who added the bronze medal that reads "Bee-she-kee, The Buffalo, a Chippewa warrior from the sources of the Mississippi. After nature by F. Vincenti, A.D. 1854. Copied in bronze by Jos. Lassalle, A.D. 1858." Beeshekee died shortly after returning to his home in 1855. The five feathers signify his valor in his nation's battles. Like Flatmouth, below, this bust originally stood in the House wing at the west staircase before it was moved here in 1981.

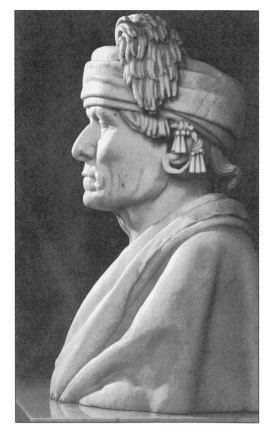

Site 147: Aysh-Ke-Bah-Ke-Ko-Zhay. Known as "Flatmouth," this chief of the Pillager band of the Chippewa Indian Nation visited Washington with Beeshekee in 1854 to complete a land treaty with President Franklin Pierce. Army Captain, later General, Seth Eastman, an aide to General Montgomery Meigs, suggested the old chief sit for a bust with sculptor Francis Vincenti. In 1855, this marble bust was completed and added to the permanent collection of the U.S. Capitol. It originally stood in the House wing at the west staircase before it was moved here in 1981. Flatmouth died in 1860.

Original
Subway Car.

Site 148: The Capitol Subway. Below, the very busy Rotunda is the Capitol basement. Take any elevator to the basement and follow the signs to the subway (about a 3-minute walk) and take it to the Hart Senate Office Building for a visit to the Sewall-Belmont House, another unique Washington, D.C. site. Or return to Union Station by riding the subway to the Dirksen Senate Office Building and taking a short walk. Or, if you have the time to discover a generally unseen part of the Capitol, take an elevator to the ground floor, continue past the first subway directional sign, and continue your tour through the Capitol basement. Walk toward the House Office Buildings until you discover high vaulted ceilings and large cavernous rooms, which were used for the storage of needed supplies during the Civil War. Barrels of flour were rolled down the stairs and used to bake bread for the surrounding encampments in ovens converted from congressional committee rooms. The basement area now houses House and Senate committee rooms, maintenance facilities, artwork, sculptures, and walking tunnels to House Office buildings [exiting at the Cannon House building will take you to the Capitol South Metro station].

New Subway
Car.

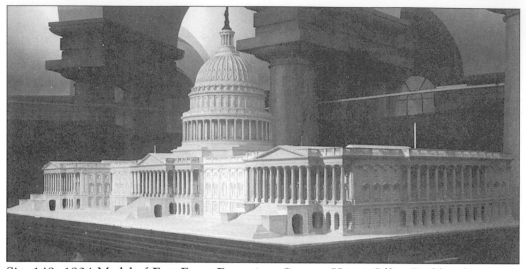

Site 149: 1904 Model of East Front Extension: Cannon House Office Building basement.
This is a much-traveled architectural model that shows how the U.S. Capitol would look when the East Front (the parking lot side) was finally extended. Created in 1904 by Emile Garet, the scale model is 1/8 inch for every 100 feet and was used as part of the official report to Congress of that year. In fact, the East Front can be removed to show what the building looked like before the completed extension in 1962. This model was sent to expositions in San Francisco in 1915; Philadelphia in 1926; Seville, Spain, in 1928; and Cleveland, Ohio, in 1937. The model was on display in the Crypt under the Rotunda from 1938 until it was moved here in 1965 [you can see the 1904 West Front extension model in the Crypt].

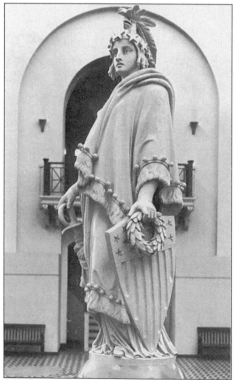

Site 150: Plaster cast of *Freedom* in the Russell Senate Office Building basement. This is the original plaster cast model for the statue of *Freedom* that sits atop the Capitol dome. Created by sculptor Thomas Crawford, the actual bronze sculpture stands 19.5 feet high and is the tallest statue in Washington, D.C. The plaster model was originally placed on display at the Arts and Industries Building of the Smithsonian Institution beginning in 1890 and was then placed in storage in 1965. In 1993 the statue was placed on permanent display here [see Site 8, page 35 for a more complete description].

Left: Site 151a: Cameron Elm. This American Elm is named for Senator Simon D. Cameron of Pennsylvania, who saved it in 1873. It is probably the oldest tree on the Capitol grounds. Brumidi painted a portrait of Cameron that hangs in S-118 (you must have special access).

Right: Site 151b: *Sequoia Gigantea.* This tree from Georgia was planted by the Cherokee Indian Nation on May 25, 1966, to commemorate the 200th anniversary of the birth of Sequoyah. He gave the Cherokee its written language in 1821. Sequoyah's bronze statue by Vinnie Ream is in Statuary Hall as a gift from Oklahoma.

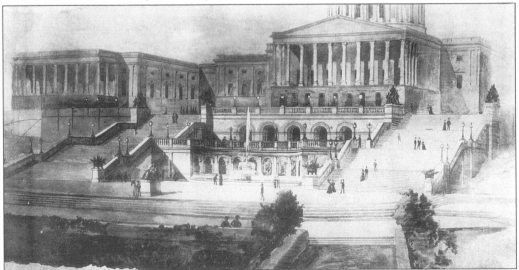

Site 151: West Front Grounds. Prior to 1874, this area of the U.S. Capitol faced the Tiber Canal with abundant wetlands and wilderness. In fact, cows still grazed on the West Grounds throughout the Civil War. However, Frederick Law Olmsted, the best-known landscape architect of his time, changed all that beginning in 1874. Fresh from designing Central Park in New York City, Olmsted began to change the character of random wilderness employed by previous landscape designers and created 212 acres of well-managed, tree-covered patches of green. Congressional staffers and visitors enjoy the grounds today in all kinds of weather.

115

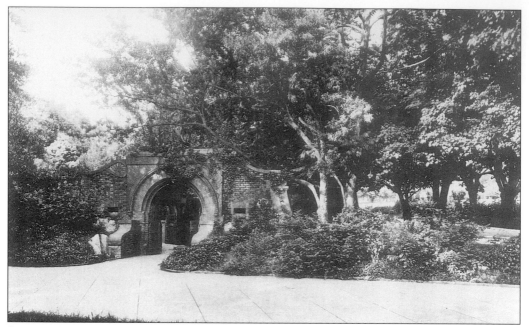

Site 152: Grotto. The entire grounds of the U.S. Capitol were designed by the internationally renowned landscape architect Frederick Law Olmsted, who was also known for designing New York City's Central Park in the mid-1870s. During this period, the Capitol grounds hosted croquet games and Easter egg rolls, and, in an 1877 report, stray cows damaged the plants and bushes. The brick enclosure to this grotto was created in 1879 as a refreshment site for fresh water. This spring was apparently used by Native Americans when they camped at the foot of Jenkins Hill and by travelers headed to Georgetown and points west. This is the grotto made famous as one of the midnight meeting places between Bob Woodward and Carl Bernstein of the *Washington Post* and their Watergate source known only as "Deep Throat." The ensuing investigation of White House wiretapping and the break-in at the Watergate office building in 1973 led to the resignation of President Richard M. Nixon on August 9, 1974—the first time an American president resigned.

President Richard M. Nixon.

Site 153: Olmsted Fountain.
This fountain was connected to the underground springs that refreshed Capitol Hill since the late 18th century. Another view of the spring can be seen in the Grotto nearby. The fountain was designed by, and therefore named for, Frederick Law Olmsted, the internationally renowned landscape architect. Olmsted died in 1903.

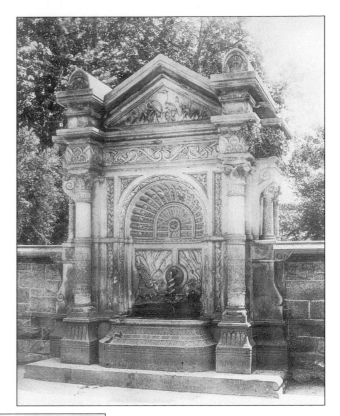

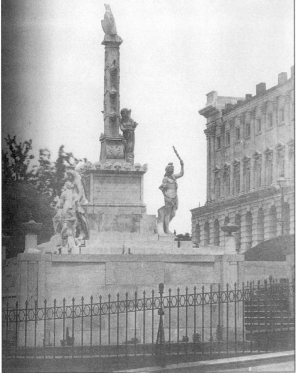

Site 154: Tripoli Monument. This was the first statue group ever erected on the grounds of the U.S. Capitol to honor American losses of the U.S. Navy in Tripoli in 1803–1804. It was originally placed in Washington's Navy Yard in 1808 but was moved to the Capitol in 1831. In 1860, the monument was removed to the U.S. Naval Academy in Annapolis, Maryland, where it still stands. The marble statue was created by Charles Micali.

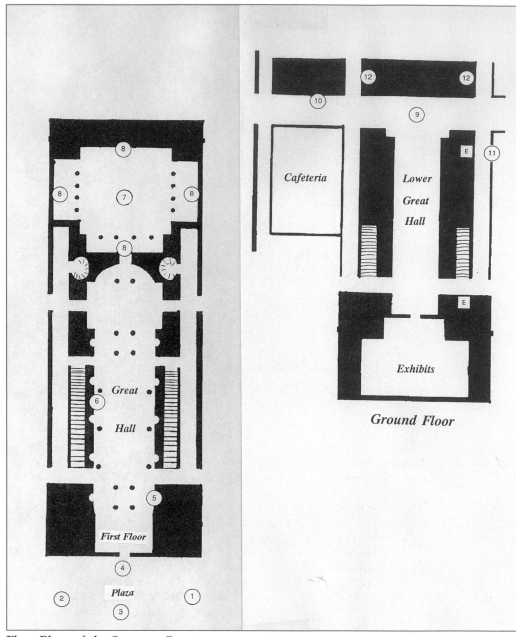

Floor Plans of the Supreme Court.

TOUR C
THE SUPREME COURT

"The Republic endures and this is the symbol of its faith."
—Chief Justice Charles Evans Hughes during the laying of the cornerstone, 1932.

The Supreme Court had a wandering life for its first 135 years in Washington, D.C. It had met in private homes, taverns, hotels, and several locations within the Capitol itself, usually near the Senate. Only in 1935 was the Court finally provided a permanent location.

Article III of the U.S. Constitution established the Supreme Court "as the judicial power of the United States" and, as such, its rulings are deemed final. This third, but equal, branch of the U.S. government acts as the appellate court for the 11 circuit courts of appeal and 94 district courts currently established to hear federal cases. Most importantly, the Court's powers can also declare state or federal laws unconstitutional. The eight associate justices and one chief justice form the Supreme Court. Once appointed by the president of the United States and confirmed by the U.S. Senate, each justice serves his or her term for life (however, a justice can be impeached by Congress).

As you walk through the Supreme Court today, its history as the guardian of the law of the United States will reveal itself in the statues and portraits of the justices who have served and continue to serve here. To better understand the internal workings of the Supreme Court itself, visit the theater on the Ground Floor for a short video presentation or purchase *Equal Justice Under Law* at the gift shop. Now, let's find out what made the Supreme Court so important to us.

Site 1: The Old Brick Capitol. On this site stood the Old Brick Capitol, built in 1815 as the temporary home of Congress after the British occupied and burned the Capitol on August 24, 1814. A stock company was created to build a temporary meeting site for Congress until the Capitol could be rebuilt. The Old Brick Capitol served Congress until 1819. President James Monroe was inaugurated outside the building on March 4, 1817, the first time the oath of office was taken outside. Except on rare occasions, this custom has been maintained ever since.

Site 2: The Old Capitol Prison. Located here, the Old Capitol Prison housed political prisoners during the Civil War. After Congress returned to the refurbished Capitol in December 1819, this building became a private school and a boardinghouse for congressmen. In 1861, the federal government installed wooden bars on the windows and used it as a prison for renegade Union officers, spies, contraband slaves, and political prisoners. The most famous prisoners were Rose O'Neal Greenhow and Belle Boyd, both celebrated Confederate spies.

Site 3: The Plaza. The area in front of the Court is 100 feet wide. On the left of the main staircase is *The Contemplation of Justice,* who is holding a statue representing Justice. On the right is *The Authority of Law.* Both were sculpted in marble by James Earle Fraser in 1935, the year the Supreme Court opened.

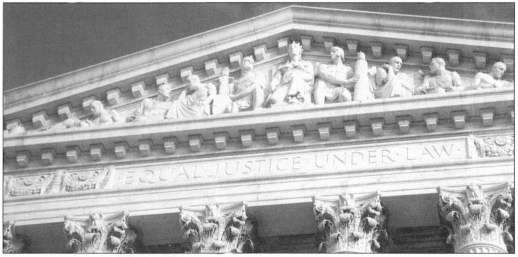

Site 4: The Sculpture Group above the Main Entrance. "Equal Justice Under Law" is inscribed in marble above the main entrance, or east facade, of the Supreme Court. Above is a pediment that is 18 feet high and 60 feet wide and begins with the allegorical figures of "Liberty" (center) with "Order" and "Authority" on either side of her. On the far left is William Howard Taft (27th president of the United States and chief justice of the Supreme Court, 1921–1930), Cass Gilbert (architect of the Supreme Court), and Elihu Root (lawyer, diplomat, Noble Peace Prize winner in 1912). To the right of "Authority" is Charles Evans Hughes (chief justice, 1930–1941), Robert Aitkin (sculptor of these statues), and John Marshall (chief justice, 1801–1835).

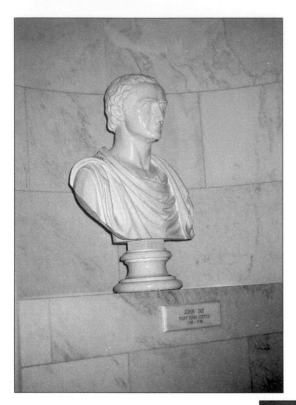

Site 5: John Jay. Appointed by President George Washington in 1789 as the first chief justice of the United States, Jay was a member and president of the Continental Congress, drafted the constitution of New York (where he was born in 1745), and helped negotiate the final peace with Great Britain after the Revolutionary War. With Alexander Hamilton and James Madison, he cowrote *The Federalist Papers*, which helped explain the new U.S. Constitution and secure its passage. After Jay left the Supreme Court in 1795, he returned to Great Britain to finalize the peace agreement as part of what is now known as Jay's Treaty and then returned home as governor of New York. John Jay died in 1829 at the advanced age of 84. Bruce Hoheb and Vencenzo Columbo sculpted this bust in 1978–1979 from a reproduction of the original bust John Frazee executed in 1831 that is located in the Old Supreme Court Chamber in the Capitol.

Site 6: William Howard Taft. Bryant Baker sculpted Taft, the 27th president of the United States, in 1932. Taft also served as chief justice of the United States Supreme Court and was the only person to hold the top office in two branches of the U.S. government. Prior to his appointment by President Warren G. Harding in 1921, Taft served as a judge of the Ohio Supreme Court, a U.S. circuit court judge, and the first governor of the Philippines after the Spanish-American War in 1901. He also served as secretary of war under President Theodore Roosevelt in 1904. It was Taft who persuaded Congress to appropriate the funds to build a separate building for the Supreme Court (they had been meeting in the Capitol). It was completed in 1935—five years after Taft's death at the age of 73.

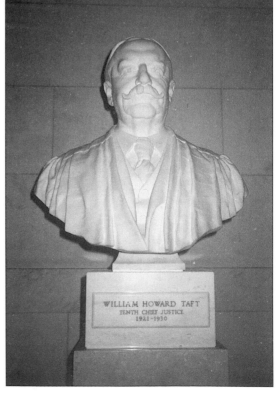

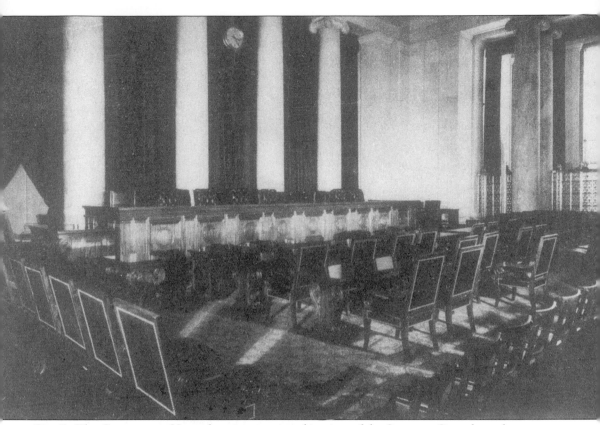

Site 7: The Courtroom. Here, the nine appointed justices of the Supreme Court hear the cases they have decided to hear. At the curved bench (the early photo above shows the original bench as straight until it was changed in 1972) located under the clock, each justice has their place dictated by the number of years they have served on the Court. The chief justice is seated in the center. The courtroom measures 82 feet by 91 feet and has a ceiling height of 44 feet. The clerk of the Supreme Court occupies the desk on the left of the bench, and the marshal of the Court occupies the right. The opposing attorneys occupy the long mahogany table across from the bench and each is allotted 30 minutes to state their case at the table-top lectern. Behind the attorneys is a brass rail. To the left are seated the press, and to the right are seated special guests of the Court. The public is seated in the benches located behind the brass rail.

Site 8: The Four Friezes. On the following two pages are four friezes, each designed and sculpted by Adolph A. Weinman during 1931 and 1932. They are 40 feet long by 7.2 feet wide and are carved from Spanish marble. The biographies of the historical figures can be found in the chamber of the House of Representatives beginning on page 89.

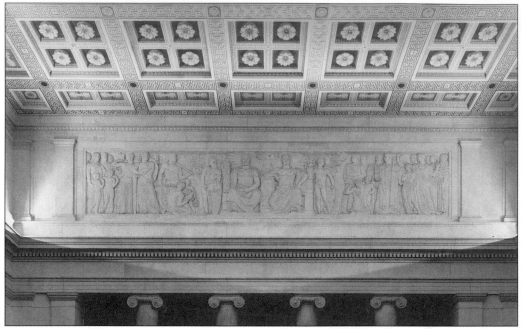

Frieze #1: East Wall Frieze (above the bench). The two central figures represent "The Majesty of Law" and "The Power of Government." They are flanked by "The Defense of Human Rights and Protection of Innocence" on the left and the "Safeguard of the Liberties and Rights of the People in their Pursuit of Happiness" on the right.

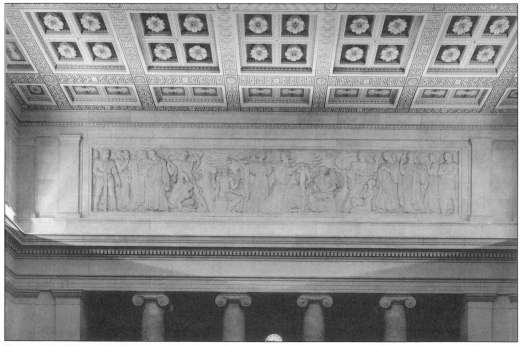

Frieze #2: West Wall Frieze (inside, above you). The two central figures here are "Justice," who is flanked by "The Powers of Good" on the left, and "Divine Inspiration," who is flanked by "the Powers of Evil" on the right.

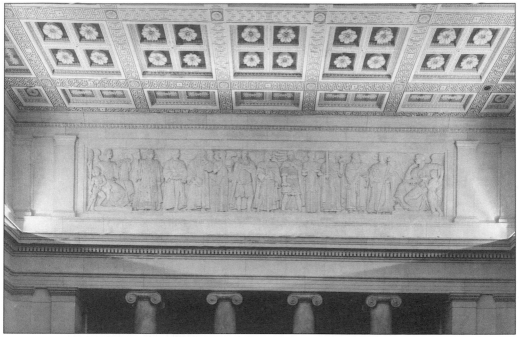

Frieze #3: North Frieze (inside, to the left). On the far right is "Philosophy," followed by Justinian, Mohammed, Charlemagne, "Equity," King John, Louis IX, Hugo Grotius, "Right of Man," William Blackstone, John Marshall, Napolean, and "Liberty and Peace."

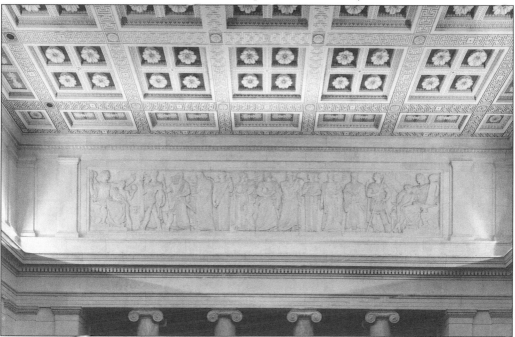

Frieze #4: South Frieze (inside, to the right). On the far left begins "Fame," who is followed by Menes, Hammurabi, Moses, Solomon, "Authority," Lycurgus, Solon, "Light of Wisdom," Draco (his Athenian code of laws of 620 B.C. were very harsh for minor offenses, thus such treatment has come to be known as "draconian"), Confucius, Octavian, and "Philosophy."

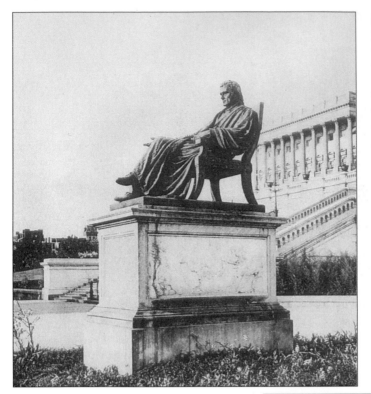

Site 9: John Marshall. During Marshall's tenure, the Supreme Court became the final authoritative interpreter of the U.S. Constitution—firmly establishing the Court as the third branch of government. Marshall helped decide over 1,200 cases during his 34 years on the bench until his death in 1835 in a stage coach accident. He was 80 years old. This 5-foot bronze statue by sculptor William Wetmore Story was cast in 1883 and was originally located on the west terrace of the U.S. Capitol until it was moved here during the reconstruction of the West Front in the 1970s.

Site 10: Oliver Wendell Holmes. Holmes served in the Union Army during the Civil War and, in 1882, became a professor of law at Harvard Law School. He was later appointed as an associate justice, then the chief justice, of the supreme court of Massachusetts, his home state since his 1841 birth. Holmes was appointed to the U.S. Supreme Court in 1902 by President Theodore Roosevelt and remained on the bench until his retirement in 1932. He died in 1935 at the age of 94. Artist Sergie Konenkov sculpted this likeness of Holmes in 1939, and it became a gift to the Court from the District of Columbia Bar Association.

Site 11: The Warren Court. Named for the 14th chief justice of the Supreme Court, Earl Warren (1953–1969), the Warren Court was known for its very progressive opinions for the times: *Brown v. Board of Education* that outlawed segregated schools in 1954 and *Miranda v. Arizona* that gave a suspect his or her "Miranda Rights" in 1966. This sculpture group was created by Phillip Ratner in 1962 and shows, from left to right, Justices Byron White, William J. Brennan, Tom C. Clark, Hugo L. Black, Warren, William O. Douglas, John M. Harlan II, J. Potter Stewart, and J. Arthur Goldberg.

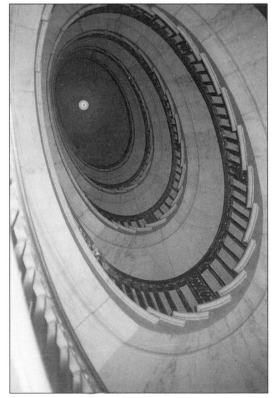

Site 12: The Spiral Staircases. For five floors these elliptical staircases create an unusual image. If you have noticed that they do not seem to be attached to anything, you're right! There are no obvious posts to hold them up—or so it seems. The stairs interlock each other to hold up the entire staircase, making this an unusual architectural surprise. Sorry, they are not for public use.

Selected Bibliography

Architect of the Capitol. *Art in the United States Capitol.* Washington, D.C.: U.S. Government Printing Office, 1976.

Brown, Glenn. *History of the United States Capitol: Volume 2.* Washington, D.C.: U.S. Government Printing Office, 1902.

Caemmerer, H. Paul. *Historic Washington: Capital of the Nation.* Washington, D.C.: Columbia Historical Society, 1966.

Capitol, The: A Pictorial History of the Capitol and of the Congress. Washington, D.C.: U.S. Government Printing Office, 1983.

Foner, Eric and John A. Garraty. *The Reader's Companion to American History.* Houghton Mifflin, 1991.

Harrell, Mary Ann and Stuart E. Jones. *Equal Justice Under Law: The Supreme Court in American Life.* Foundation of the Federal Bar Association, 1995.

Immigration and Naturalization Service, U.S. Department of Justice. *Government Structure: Level I.* Washington, D.C.: U.S. Government Printing Office, 1987.

Lord, Walter. *The Dawn's Early Light.* W.W. Norton & Company, 1972.

Seale, William. *The White House: The History of an American Idea.* American Institute of Architects Press, 1992.

Smith, Page. *A New Age Now Begins: A People's History of the American Revolution.* McGraw Hill, 1976.

U.S. Capitol Historical Society. *We, the People: The Story of the United States Capitol.* 1985.

U.S. Senate. *The Brumidi Corridors.* Pamphlet series. U.S. Senate Commission on Art, Office of Senate Curator, S. Pub. 105-40.

Viles, Philip H. *National Statuary Hall: Guidebook for a Walking Tour.* Self-published, 1995.

White House, The: An Historic Guide. Washington, D.C.: White House Historical Association, 1962.

Works Progress Administration. *Washington City & Capital.* American Guide Series, 1937.

Photo Credits